Jackie

ALSO BY JAMES SPADA

Streisand: Her Life
More Than a Woman: A Biography of Bette Davis
Peter Lawford: The Man Who Kept the Secrets
Grace: The Secret Lives of a Princess
Fonda: Her Life in Pictures
Shirley and Warren
Hepburn: Her Life in Pictures
The Divine Bette Midler
Monroe: Her Life in Pictures
Streisand: The Woman and the Legend
The Spada Report
The Films of Robert Redford
Barbra: The First Decade

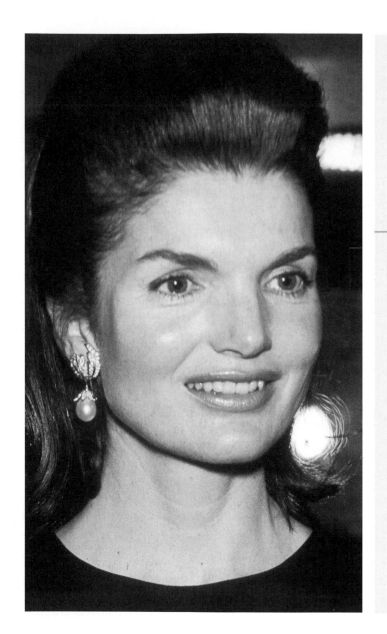

Her Life in Pictures

Jackie

JAMES SPADA

ST. MARTIN'S PRESS

NEW YORK

Photo credits appear on page 175.

Book design by James Sinclair

ISBN 0-312-25327-3
First Edition: May 2000
10 9 8 7 6 5 4 3 2 1

For Terry Brown,
who brought contentment
back into my life

contents

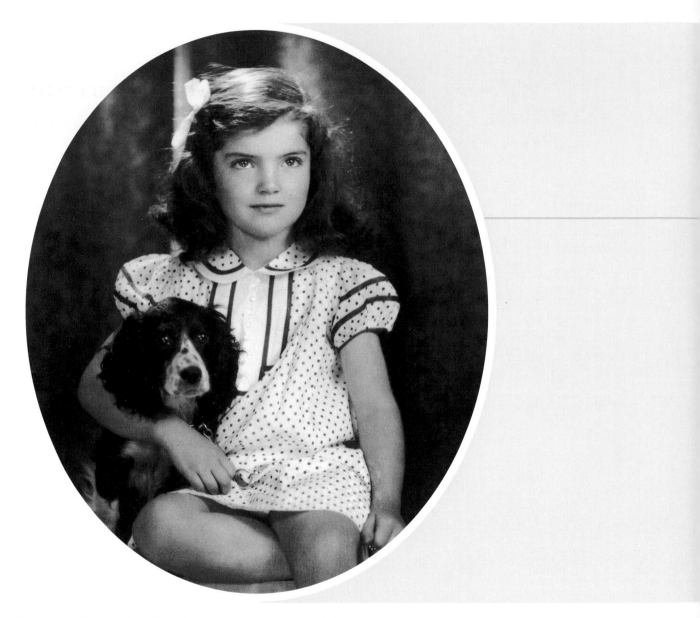

Six-year-old Jacqueline Lee Bouvier poses prettily with her beagle, Bonnet, in 1935.

To the Manner Born

Her manner and carriage proclaimed her a thoroughbred, this child Jacqueline Lee Bouvier. Pretty and sepia-haired, she charmed without effort. Her smile flirted. Her wide-set, green-brown eyes missed little.

Privilege cushioned her world. Her home on Park Avenue, not far from the Metropolitan Museum, fueled a love of art and a sophistication. Idyllic summers at Lasata, her grandparents' estate on Long Island Sound in East Hampton, bequeathed to her a love of the water, and horses, and solitude. "I only care for the lonely sea/And I always will, I know," she wrote at thirteen. "For the love of the sea is born in me/It will never let me go."

Her wit and intelligence shone. Her mind absorbed information more quickly than other students, and her impatience prompted misbehavior. A school headmistress, at first at a loss, finally told Jackie that she reminded her of a thoroughbred horse. But what good would a great racehorse be, she asked, "if he wasn't trained to stay on the track, to stand still at the starting gate, to obey commands?" The analogy impressed the young equestrian. The filly stopped champing at the bit and allowed her trainers to break her in properly.

There were private sorrows. Her parents argued, separated, divorced. Moodiness and sensitivity leavened her effervescence now. Her schoolgirl poetry richly evoked the senses: "Along the waterfront I go/And hear the steamers' empty sighs/The river laps against the docks/And in the fog a seagull cries."

All who knew her sensed a potential for greatness. Perhaps she'd become a poet or a novelist. Before setting off to college, she proclaimed an ambition not to be a housewife. Few doubted she'd succeed at whatever she did. Even as early as grade school, her art teacher said, she was someone you'd never forget.

Mrs. John Bouvier proudly displays her big-eyed baby daughter, Jacqueline Lee, for a Christmas portrait in 1929. The child had been born the prior July 28. The former Janet Lee, Jackie's mother was born into wealth and privilege as the daughter of the chairman of the New York Central Savings Bank, James T. Lee, and Margaret Merritt Lee. Embraced by the Long Island "East Egg" set made famous by F. Scott Fitzgerald in *The Great Gatsby,* Janet became an accomplished horsewoman, studied at the finest schools, and lived in an eleven-room apartment with a gymnasium in one of Park Avenue's finest buildings.

When Janet was a teenager, her father discovered that her mother was having an affair. He moved out, and the Lees communicated only through Janet, whose forlorn task it was to shuttle messages back and forth between them.

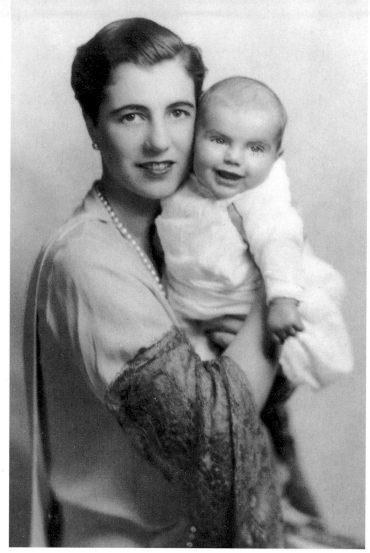

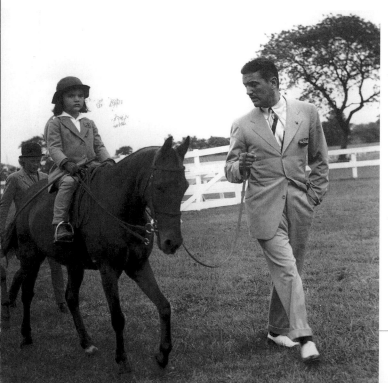

At the Smithtown, Long Island, horse show in August 1933, John Vernou Bouvier III leads his four-year-old daughter in line class. The little girl adored her handsome, dashing father, a stockbroker known as Black Jack because of his inky hair and imperishable year-round tan. "He was powerful, wealthy, exotic, and undeniably, darkly attractive," his niece Kathleen Bouvier said. Jackie agreed. "A most devastating figure," she called him.

Four-year-old Jackie holds the hand of her infant sister, Caroline Lee, born in May of 1933. Although not as wealthy as the Lees, Black Jack Bouvier's family enjoyed a higher social status, due in part to a Bouvier genealogy his grandfather published privately in 1925 (and sent to genealogy societies across the country) that traced the family ancestry back to the sixteenth-century French aristocrat François Bouvier of "the ancient house of Fontaine."

The Bouviers' actual forebear was an ironmonger of the same name who lived two centuries later. Whether the mistake was purposeful or inadvertent, the genealogy, and the impressive family crest the Bouviers adapted from that of the house of Fontaine, brought them social acceptance as that rarest of breeds—a family descended from nobility.

By the age of six, little Jackie had proved to be a handful. Although she appears the model student in this photo outside Miss Chapin's School on Manhattan's East End Avenue, her misbehavior got her sent to the headmistress's office nearly every day. "Her problem at Chapin," her mother said, "was sheer boredom. Jackie would finish her lessons before any of the other children and, lacking things to do, would make a nuisance of herself."

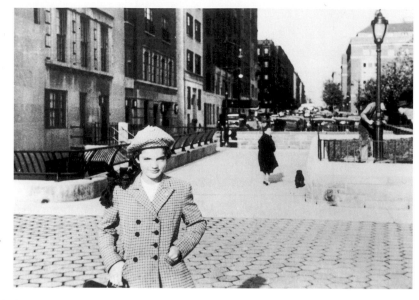

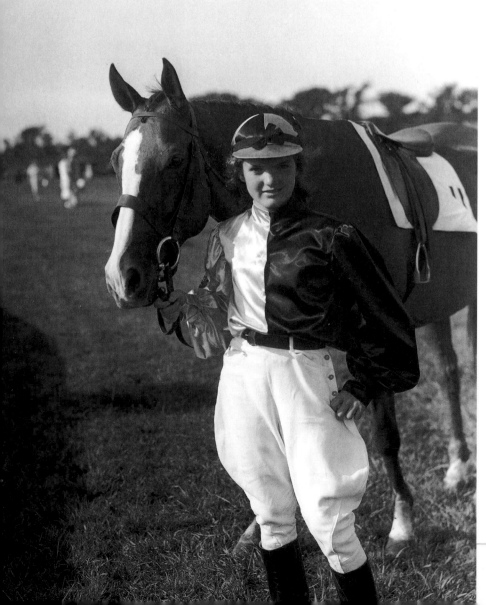

Thirteen-year-old Jackie poses confidently next to her horse, Danseuse, at the East Hampton, Long Island, Horse Show in August 1942. From her first show at the age of four, Jackie had proved herself a determined competitor. Observers always could tell how Miss Bouvier had fared—if she hadn't won a ribbon, her face would be etched with a scowl. She won more than her share, as well as the admiration of fellow riders. One recalled her as "damned plucky. She'd get tossed on her butt while taking a jump and a moment later she'd be scrambling to climb back on."

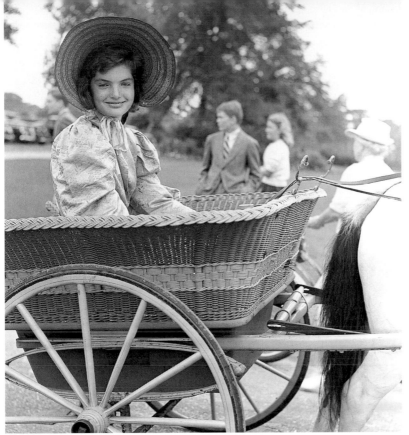

"I was a tomboy," Jackie said. "I decided to learn to dance and then I became feminine." At a costume-class event at the 1942 East Hampton Horse Show, Miss Bouvier appears not only feminine but exceedingly lovely.

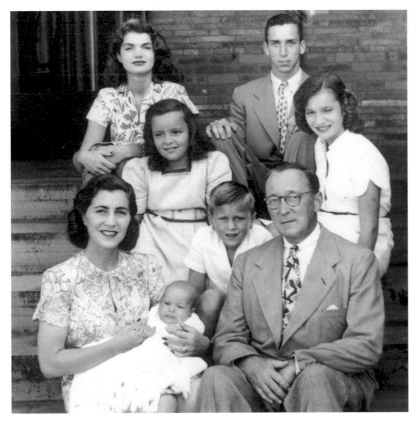

Jackie, sixteen, poses with her new family for a Christmas portrait in 1945. Her parents had divorced in 1940, mainly because of Black Jack's philandering, and two years later Janet married Hugh Auchincloss, an investment banker with a huge family fortune. They divided their time between Merrywood, a forty-six-acre estate overlooking the Potomac in McLean, Virginia, and the sprawling Hammersmith Farm in Newport, Rhode Island, which featured a mansion with twenty-eight rooms.

In this photo, Janet holds the newborn Janet. Next to her sits Hughdie and his son Thomas. In the row above are Nina Auchincloss and Lee Bouvier. At top are Jackie and Hugh D. III, known as Yusha.

7

"Ambition: Not to be a housewife."
Jackie's graduation yearbook entry at Miss Porter's School, from which she was graduated in June of 1947. She boarded at the Farmington, Connecticut, school for three years, won good grades, and distinguished herself with both her love of learning and her hijinks. An editor of the school newspaper, she stuffed the dorm's fire alarm bell with paper before a drill. While serving as a member of a student leadership group, she "accidentally" dumped a pie in the lap of a teacher while clearing plates from the dining room.

She was well liked but had few close friends. The closest was her roommate, Nancy Tuckerman (the "Tucky" of her yearbook entry), whom she had known

JACQUELINE LEE BOUVIER
"MERRYWOOD"
MC LEAN, VIRGINIA
"Jackie"

Favorite Song: Lime House Blues
Always Saying: "Play a Rhumba next"
Most Known For: Wit
Aversion: People who ask if her horse is still alive
Where Found: Laughing with Tucky
Ambition: Not to be a housewife

since her days at Miss Chapin's School. She spent a great deal of time in her room reading, writing, and drawing. She drew a regular comic strip for the school paper, *Frenzied Frieda,* which chronicled a young woman who could never seem to keep herself out of trouble.

Jackie admires her coming-out dress in her bedroom mirror at Hammersmith Farm in August 1947. The society columnist Cholly Knickerbocker wrote of Jackie: "Every year a new Queen of Debutantes is crowned. Queen Deb of the Year is Jacqueline Bouvier, a regal brunette who has classic features and the daintiness of Dresden porcelain. She has poise, is soft-spoken and intelligent—everything the leading debutante should be."

About to enter Vassar College, Jackie now considered herself grown-up—especially since, she recalled, "I learned to smoke, in the balcony of the Normandie Theater in New York, from a girl who pressed a Longfellow upon me, then led me from the theater when the usher told her that other people could not hear the film with so much coughing going on."

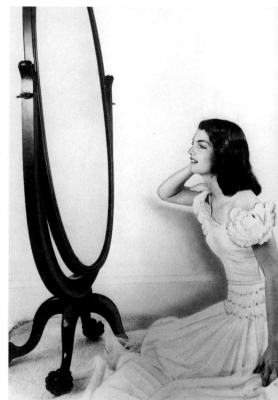

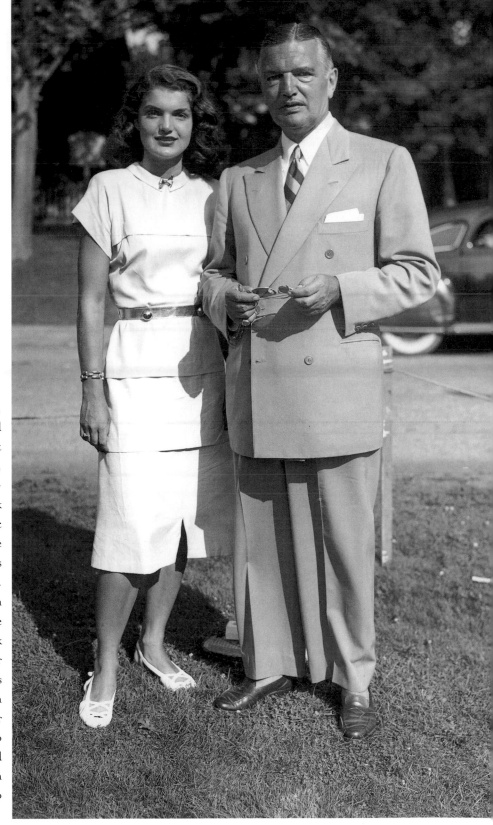

Black Jack Bouvier, now fifty-six, poses with his eighteen-year-old daughter in 1947. Janet felt great enmity toward her ex-husband, and her vilification of him devastated Jackie. To her, Black Jack was a larger-than-life, romantic figure whose life on the edge she found exciting. She never held his marital infidelities against him. The writer Truman Capote, a family friend, described the Bouvier family dynamic: "I think [Jackie] could appreciate that her mother was this sort of hideous control freak, a cold fish with social ambitions, and her father was a naughty, naughty boy who kept getting caught with his hand in the cookie jar. Of course, both girls loved him more. Who wouldn't, given the choice?"

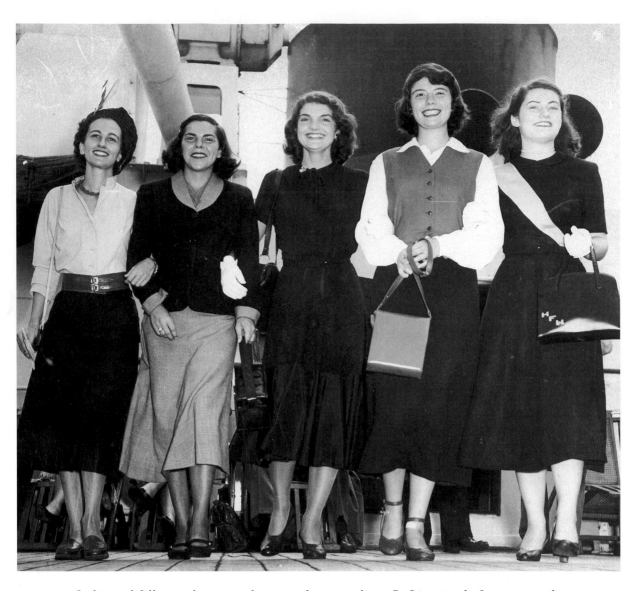

Jackie and fellow exchange students on the ocean liner *De Grasse* just before it set sail on August 24, 1949. Jackie's superb intelligence had brought her high grades her first two years at Vassar, but she found its small-town college atmosphere constricting. She longed to return to France, which had beguiled her when she first visited the country the summer after her freshman year. Now she would spend her junior year studying at the Sorbonne, and she was thrilled.

She lived with a French family in a small Paris apartment, where she spoke French exclusively. Accustomed to creature comforts, Jackie had a hard time adjusting to the postwar energy restrictions. She spent most of her time "swaddled in sweaters and woolen stockings," she wrote home, and once when she tried to increase her bathwater temperature, the hot-water heater exploded, shattering the bathroom window. Still, her love for Paris and all things French grew.

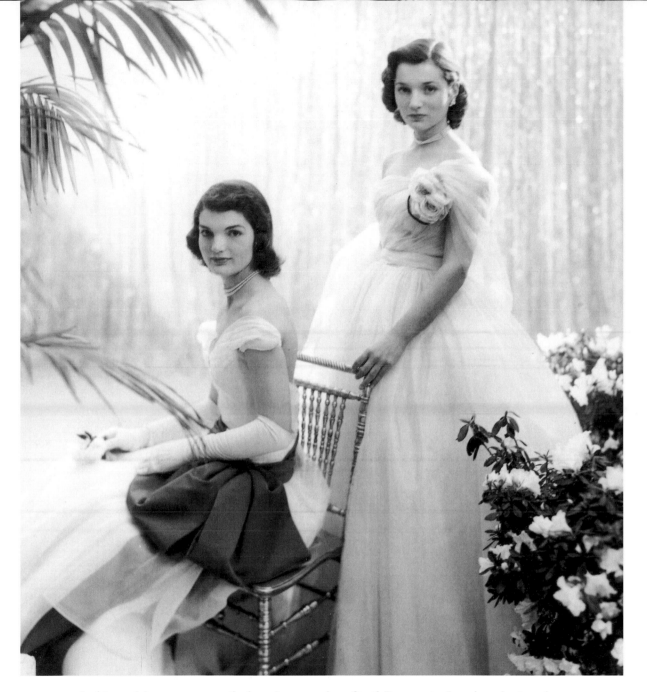

Jackie and Lee pose prettily for photographer Cecil Beaton in London during the summer of 1951. The trip to England and the Continent was a consolation offered to Jackie by her stepfather, who had talked her out of accepting a prize she'd won in a *Vogue* magazine contest. The prize included six months working at the publication's Paris bureau, and Hugh Auchincloss feared that Jackie might elect to stay in France permanently if she spent another extended period there.

Of all the enrichments her periods spent abroad had brought her, Jackie wrote, the most important was that she had "learned not to be ashamed of a real hunger for knowledge, something I had always tried to hide."

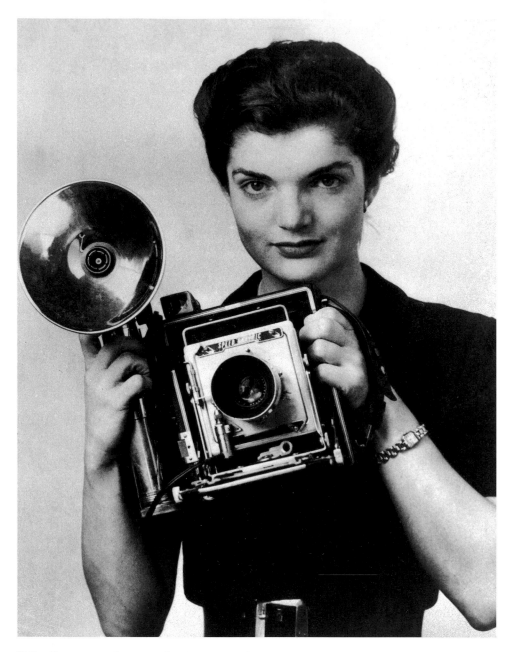

"The Inquiring Camera Girl." When she returned from her summer in Europe, Jackie decided she wanted to work. Her stepfather, a Republican, helped her get a job as a receptionist to the editor of the conservative *Times-Herald* in Washington, D.C. Within weeks she asked her boss to let her do some writing. He needed an inquiring photographer and asked her if she knew how to handle a Speed Graphic. She assured him she did, then signed up for a crash course in using the bulky professional camera.

She became proficient enough as a photographer, but it was the often-provocative questions she posed that made readers take notice of the column. "Would you rescue a great artist who is a scoundrel, or a commonplace, honest family man?" she asked for one column. For another, "If you had a date with Marilyn Monroe, what would you talk about?" After a few months one could discern a feminist cast to many of the queries: "Do you think a wife should let her husband think he's smarter than she is?" Finally she posed questions that were more statement than query: "When did you discover that women are not the weaker sex?"

Shortly after she began work at the *Times-Herald,* Jackie became engaged to John Husted, a tall, handsome Yale man and friend of the family. For Husted, it was love at first sight, and within weeks, he said, "we had sort of declared our love for each other." In January of 1952 they became engaged.

Jackie's friends and family were skeptical about the union. "He didn't have the same interests that Jackie had," Yusha Auchincloss recalled. "He was a banker, he belonged to all the right clubs, but that was about it." The long-distance nature of the relationship (Husted worked in New York) didn't help, and neither did Jackie's new independence. She enjoyed being out in the world, earning her own living, and both of these new experiences changed her mind about marrying Husted. "I knew I didn't want the rest of my life to be [in Newport]. I didn't want to marry any of the young men I'd grown up with—not because of them but because of their life."

After a few months, Jackie broke off the engagement. By then matchmaking friends had brought her together once again with a man they thought would be perfect for her.

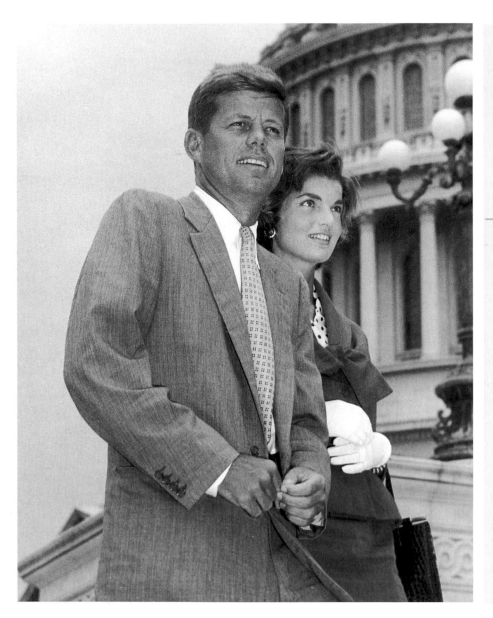

Senator and Mrs. John F. Kennedy on the steps of the United States Capitol in
1955.

Senate Wife

Their paths had crossed. At first randomly, anonymously; later by design. On a train back to Vassar after a visit home to Merrywood in 1948, Jackie wrote of meeting a fellow passenger, a "tall, thin young congressman with very long reddish hair, the son of an ambassador." He had ardently flirted with her.

Three years later, at a dinner party in the home of friends, their mutual attraction glowed. The contrasts in each most intrigued the other. Jack Kennedy's boyish looks belied his rapier intelligence, while his thin, sickly frame and soulful eyes softened the power inherent in his position and wealth.

Her beauty mesmerized; her yielding femininity promised much. But the sparkle of her repartee surprised him, and during an after-dinner game of charades, her competitiveness, so like his own, challenged him pleasurably. He invited her and other friends to the Kennedy retreat in Palm Beach during the winter of 1951.

Still, they drifted apart. Congressman Kennedy immersed himself in his successful campaign to become the junior senator from Massachusetts, and Miss Bouvier accepted John Husted's proposal. Once it was clear that her engagement would not last, Jack Kennedy began a "spasmodic" courtship. "He'd call me from an oyster bar on the Cape with a great clinking of coins," Jackie recalled, "to ask me out to the movies the following Wednesday."

Friends warned Jackie that her new beau possessed a particularly keen interest in the opposite sex. She admitted to her friend Molly Thayer that she was frightened of falling in love with Jack, because she believed he did not want to be married. She "envisioned heartbreak," Thayer said, "but just as swiftly determined that heartbreak would be worth the pain."

The tinge of danger that swathed Jack Kennedy brought Black Jack to mind. "They were very much alike," Jackie said. Finally, she admitted it. "I want to marry him more than anything in the world."

The camera girl photographs the recently sworn-in senator from Massachusetts for her column in April 1953, asking him and Vice President Richard M. Nixon to comment on the Senate pages while two pages commented on them.

Joseph P. Kennedy, eager for his son's career to take him to the highest office in the land, knew that Jacqueline Bouvier would be a political asset to Jack, and urged him to marry her. As Jack began to broach the idea of engagement, Jackie used her column as a sounding board on the issue—and as the means for an occasional tweak to her suitor. Jack reportedly burst into laughter one morning when he picked up the *Times-Herald* and saw that

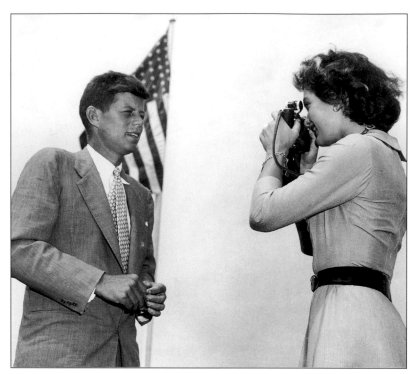

day's question: "Can you give me any reason why a contented bachelor should ever get married?"

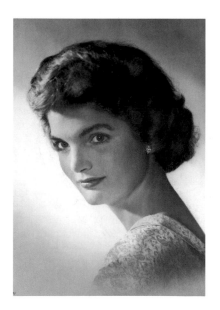

This photograph accompanied the June 24, 1953, newspaper announcement of the thirty-six-year-old Senator John F. Kennedy's engagement to "Newport Socialite" Miss Jacqueline Lee Bouvier, twenty-four.

The senator's resolve to pop the question had been cemented by Jackie's trip to England to cover the coronation of Queen Elizabeth II for the *Times-Herald* late in May. ARTICLES EXCELLENT BUT YOU ARE MISSED, he wired her. When she returned, she accepted his proposal and he presented her with a diamond-and-emerald ring from Van Cleef & Arpels. "I'm the luckiest girl in the world," she said.

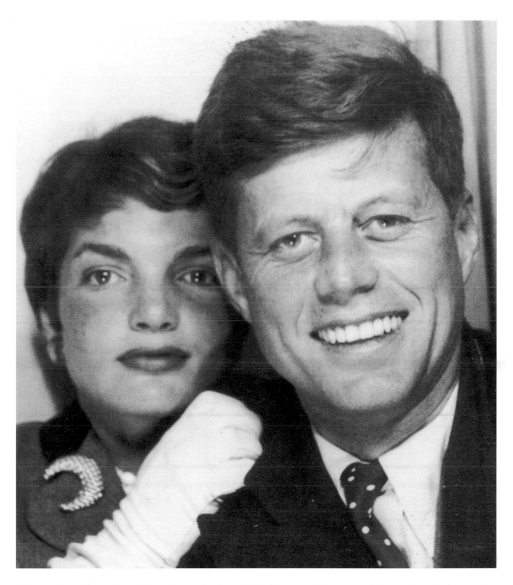

Dressed to the nines for a date, Jack and Jackie pose for one of a series of photos in a penny arcade booth. Jack carried the strip of four pictures in his wallet and showed it to his friend and aide Dave Powers. "I have never met anyone like her," he marveled. "She's different from any girl I know."

Jackie found herself slightly amused by Jack Kennedy. "He's become so vain he has to have a hairdresser come in practically every day," she told her cousin John Davis, "so his hair will always look bushy and fluffy. If we go to a party or some reception or something and nobody recognizes him, or no photographer takes his picture, he sulks afterwards for *hours*."

What most amused Jackie about her fiancé were his pie-in-the-sky ambitions. "He even told me he intends to be *president* someday!" she said. Then she roared with laughter at the absurdity of it.

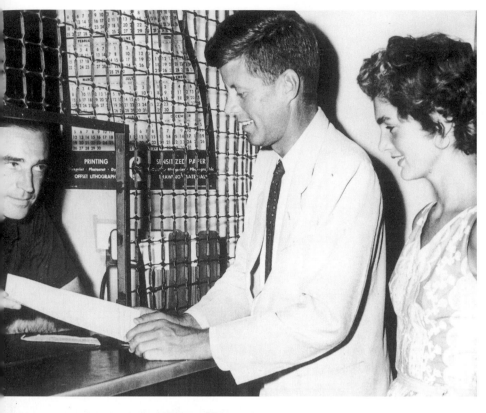

Jack and Jackie apply for their marriage license in September 1953. The impending nuptials generated a great deal of press interest, particularly because of Jackie's glamour and the fact that Jack had recently been the subject of a *Saturday Evening Post* cover story entitled "The Senate's Gay Young Bachelor."

On September 12, 1953, in Newport's century-old St. Mary's Church, the couple kneel for the high nuptial Mass celebrated by Boston's Archbishop Richard Cushing.

Her wedding day proved bittersweet for Jackie. She was shocked by the more than three thousand gawkers and journalists who mobbed her as she arrived at the church, but far worse was her father's absence from the ceremony. The Auchinclosses had excluded him from all of the prewedding parties and blocked his telephone calls to Jackie, which devastated him. The morning of the wedding, upset and nervous, he began to drink. Although two of his brothers-in-law assured Janet that Black Jack was still able to perform his duties, the fear of embarrassment led her to bar him from the church. Hugh Auchincloss took Black Jack's place and walked the bride down the aisle.

Later Jackie wrote her father a note saying that she understood the pressure he had been under and that, in her heart, it was he who had given her away.

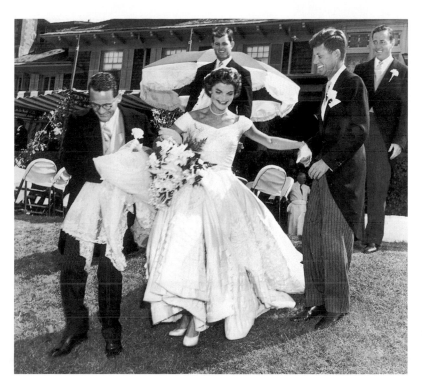

On the sprawling lawn of Hammersmith Farm, Mrs. John F. Kennedy is escorted down an embankment to pose for wedding pictures with her husband, her brother-in-law Ted, and wedding party members Charles Bartlett, left, and Torbert Macdonald. Bobby Kennedy had served as best man, and Jackie's sister Lee, married to Michael Canfield the prior spring, acted as matron of honor.

Jackie's veil, a soft yellowed rose-point lace that had been her grandmother's, flowed several yards behind her and topped an ivory taffeta gown with ten rows of ruffles above the hem.

The honeymoon. After two nights at New York's Waldorf-Astoria, they flew to Acapulco to stay at a lavish villa owned by the president of Mexico. The week-long holiday "all went so fast," Jackie later said.

The couple then spent several days at the Beverly Hills mansion of Marion Davies. From there they drove to San Francisco, where Jack was reunited with his Navy shipmate Red Fay, with whom he took in football games—without Jackie.

She had few illusions about married life. "Since Jack is such a violently independent person," she said, "and I too am so independent, this relationship will take a lot of working out."

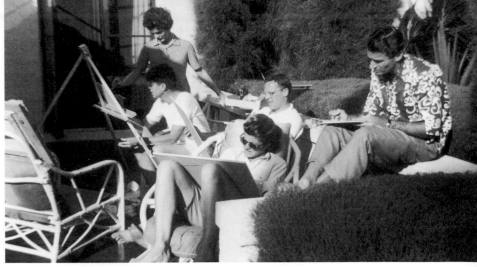

Celebrating Christmas 1953 at the Kennedys' beachfront home in Palm Beach, Jack and Jackie paint a canvas while Pat Kennedy and her soon-to-be-husband, Peter Lawford, work on their own masterpieces, along with close family friend Lem Billings.

The Kennedy siblings sometimes overwhelmed Jackie. They descended on the paint set that she had given Jack as his Christmas present, seemingly racing with each other to see who could finish a canvas first. They dripped paint on the carpets until Rose banished them to the bathrooms, and when Jackie saw how the expensive oils had been cannibalized, she barely controlled her anger.

Jackie often found her in-laws' rambunctiousness off-putting. But she saw another side to it as well. "They were like carbonated water," she reflected for Rose Kennedy's memoirs. "They'd be talking about so many things with so much enthusiasm. Or they'd be playing games. . . . They had so much interest in life—it was so stimulating."

They weren't always so accepting of Jackie, who here strolls the streets of Georgetown with Jack and Bobby's wife, Ethel, in 1954. At first, egged on by the down-to-earth Ethel, Jack's sisters Eunice and Jean mocked Jackie's sophisticated airs, calling her "The Deb." They made fun of her whispery voice and howled when she turned up her nose at the peanut butter and jelly sandwiches Ethel had packed for an afternoon sail and instead ate pâté and quiche. When Jackie mentioned that she had once hoped to become a ballerina, Ethel hooted and said, "With those big feet of yours? You'd be better off going in for soccer, kid."

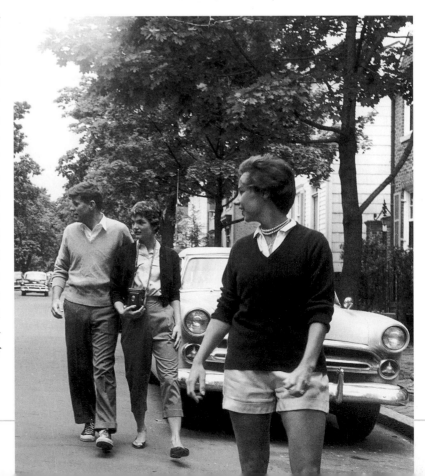

Rose and Joseph Kennedy pose with their daughter-in-law at the Everglades Club in Palm Beach in March of 1954. Jackie never warmed to Rose, whom she found overbearing, although she came to admire her strength of character.

Old Joe, however, she adored. Next to her husband and father, she said, "I love him more than anybody in the world." They avidly discussed "everything from classical music to the movies," and Joe appreciated the fact that she never cowered in the face of his wealth and power. "I used to tell him that he had no nuances, that everything with him was either black or white, while life is so much more complicated than that. But he never got angry with me for talking straight with him; on the contrary, he seemed to enjoy it."

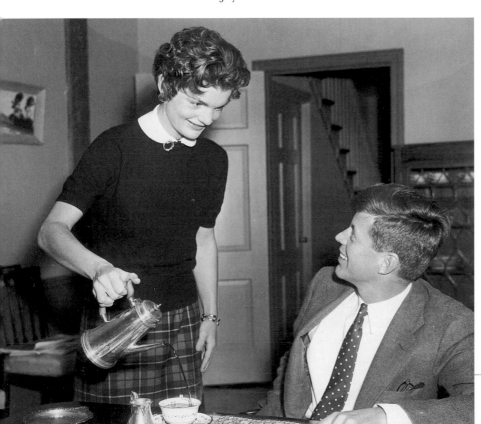

After months of living either in Jack's old bachelor pad, at the Kennedy compound in Hyannis Port, or at Merrywood, the newlyweds rented a nineteenth-century townhouse in Georgetown. In this photo, taken in the early fall of 1954, Mrs. Kennedy does her morning wifely duty before leaving for her class in American history at Georgetown University's School of Foreign Service. She took the class in order to better hold her own in the discussions of American history, social policy, and politics that went on in Washington.

Jackie waves to her poodle, Gaullie (after Charles de Gaulle), through the French doors that led from the dining room to the patio. She made a great effort to domesticate herself, but she'd never cooked an entire meal. The couple had a maid and a cook, but Jackie decided to surprise Jack with a dinner prepared with her own hands.

"I just knew everything was going right," Jackie recalled, "when suddenly, I don't know what went wrong, you couldn't see the place for smoke. And when I tried to pull the chops out of the oven, the door seemed to collapse. The pan slid out and the fat splattered. One of the chops fell on the floor but I put it on the plate anyway. The chocolate sauce was burning and exploding. What a smell! I couldn't get the spoon out of the chocolate. It was like a rock. The coffee had all boiled away. I burned my arm, and it turned purple. It looked horrible. Then Jack arrived and took me out to dinner."

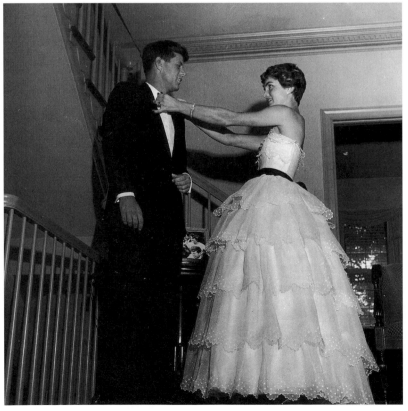

Washington's most glamorous couple prepare to leave for a social function in the fall of 1954. Early on, Jackie decided she needed to spiff up her long-time-bachelor husband's image. "He no longer went out in the morning with one brown shoe and one black shoe on," she said. "His clothes got pressed and he got to the airport without a mad rush because I packed for him."

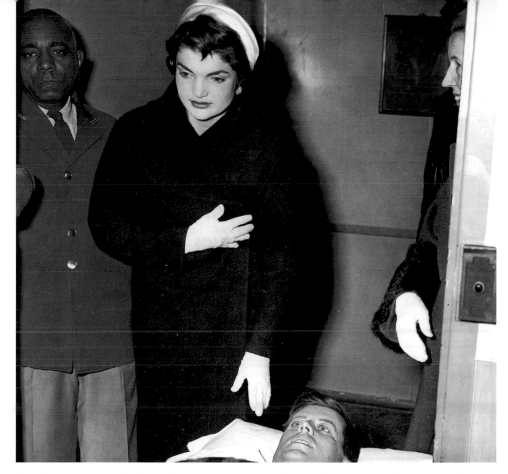

In October 1954, Jack underwent surgery to relieve chronic lower back pain that was so excruciating he sometimes couldn't walk without crutches. The operation was extremely risky, particularly since Jack suffered from Addison's disease, a malfunction of the adrenal glands that causes suppression of the immune system. Despite his father's adamant opposition, Jack opted for the surgery: "I'd rather be dead than spend the rest of my life on crutches."

After the procedure, as feared, an infection set in. Jack lapsed into a coma and received his last rites. "It was the first time I really prayed," Jackie admitted. She sat by her husband's bed constantly, talking to him while he remained comatose. After he regained consciousness she tended to him as a duty nurse and answered the hundreds of get-well wishes that flooded into his room.

On the wall of his room Jack had hung—upside down—a poster of the country's most popular movie star, Marilyn Monroe, standing with her legs wide apart. If Jackie minded, she didn't say so.

Jack's operation didn't work, and in February he underwent another. In this photo Jackie stays by his side as he is wheeled out of the hospital. The couple repaired to Palm Beach, where Jack recuperated slowly, again with Jackie's help. Rose Kennedy recalled, "The incision was very large, and it was draining, and the dressings had to be changed several times a day. Jackie did this skillfully and gently and calmly, and made no comments about it to anyone."

Fewer than three months later, Jack was back at work in Washington, still in pain but able to walk without crutches. In June, he and Jackie attended a glittering reception at the Italian Embassy in honor of that country's ambassador to the United States.

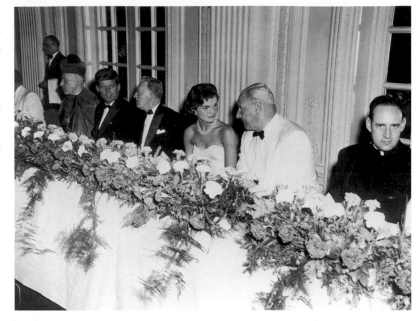

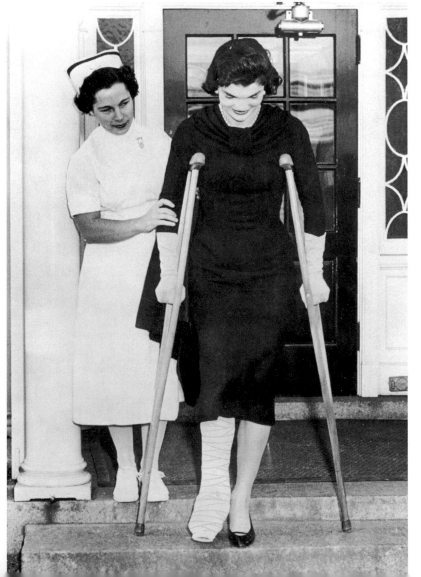

In the fall of 1955, Jackie experienced health problems of her own. She miscarried in October, and in November she broke her ankle during a football scrimmage in Hyannis Port. Riding and swimming were Jackie's only athletic pursuits; she didn't much enjoy the rough-and-tumble Kennedy touch-football games but was goaded into participating. During her engagement she moaned to a friend, "They'll kill me before I ever get to marry him, I swear they will."

The Kennedys arrive for a reception in the Senate Office Building in 1956. By now Jackie had warmed to the role of Senate wife, although she never came to share her husband's avid interest in politics. She proved gracious in receiving lines, and invariably charmed audiences with her wit, intelligence, and ability to speak French and some Spanish and Italian.

By now she had become a political asset to Jack in other ways as well. She improved his speaking style by helping him slow down and stop fidgeting. She wrote his statement of support for Adlai Stevenson's nomination for president in 1956, and she helped research and write his Pulitzer Prize–winning book *Profiles in Courage.*

In August 1956, Jackie accompanied her husband to the Democratic National Convention. She had laughed initially at Jack's ambition to be president, but by this time the vice presidency, at least, seemed well within his grasp. He came close to winning the nomination, but lost to Estes Kefauver.

The convention proved stressful for Jackie; she was eight months pregnant, and she once had to break into a run in a parking garage to avoid a reporter. On August 23, staying at Hammersmith Farm while Jack vacationed in Europe, she began

to hemorrhage and collapsed. An emergency cesarean section failed to save the baby girl, who was stillborn. Jack and Jackie were devastated. Jackie's "losing the baby," Joe Kennedy wrote to a friend, "has affected [Jack] more than his illness did that bad year." After two tries, they both began to wonder if they would ever be parents.

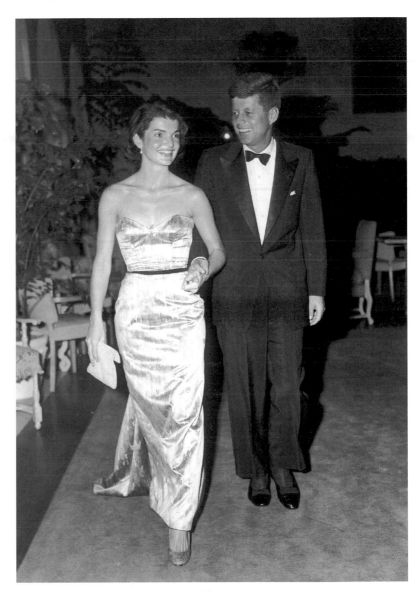

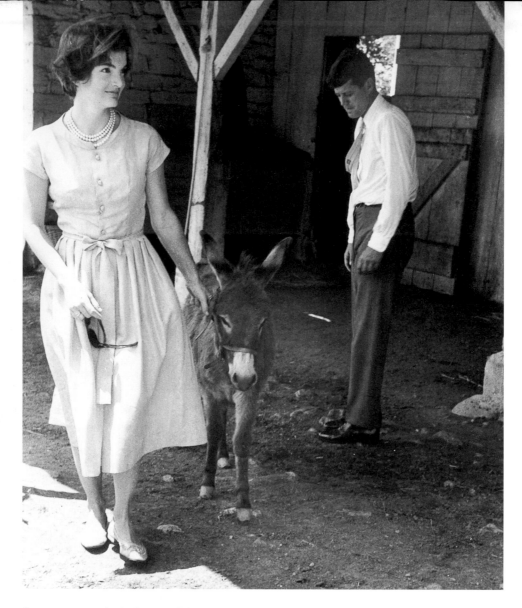

June 1957: Jack, Jackie, and friend at Hickory Hill, a farm in McLean, Virginia, that the couple had purchased in 1955 and sold a year later to Bobby and Ethel.

Her marriage had been through a difficult period—illnesses, unsuccessful pregnancies, Jack's frequent absences while traveling, rumors of his infidelity—but Jackie was determined to stick it out. "Look," she later said, "it's a trade-off. There are positives and negatives in every situation in life. You endure the bad things, and you enjoy the good. . . . If the trade-off is too painful, then you just have to remove yourself . . . but if you truly love someone, well . . ."

In the spring of 1957, Jackie became pregnant again. Her joy was tempered by the death of her father on August 3, at the age of sixty-six. She felt particularly grief-stricken that she had not been present when he died; the last word he uttered was "Jackie." She arranged his funeral service at St. Patrick's Cathedral and wrote his obituary notice for *The New York Times*.

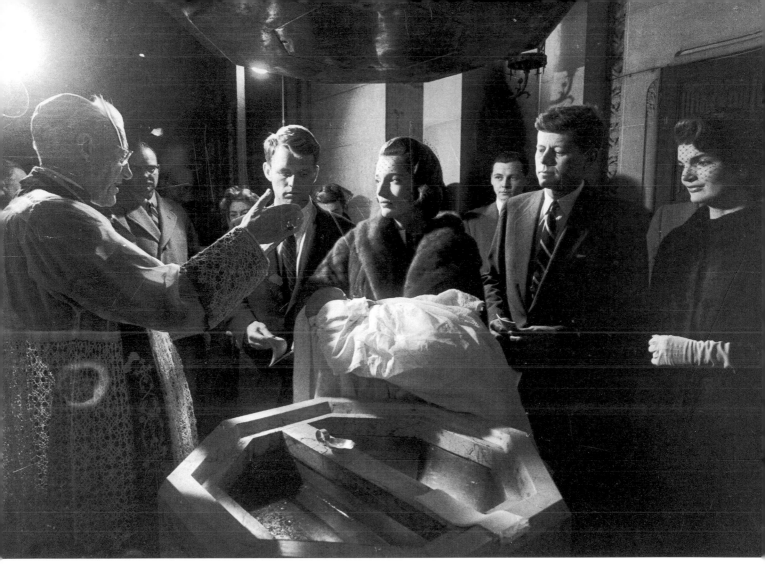

On November 27, 1957, Jack and Jackie's fondest wish came true: Jackie gave birth, without complication, to a healthy baby girl they named Caroline Bouvier. Jackie's mother recalled, "I'll always remember Jack's face when the doctor came into the waiting room and told him that the baby had arrived and that it was a girl and that Jackie was fine and the baby was fine. . . . I don't remember that he said anything. I just remember his sweet expression. . . ."

Above, Archbishop Cushing christens the newest Kennedy at St. Patrick's Cathedral in New York on December 15, 1957. In the foreground are Cushing, godparents Bobby Kennedy and Lee Bouvier Canfield, and the proud parents. Visible behind Jack is his brother-in-law Stephen Smith, Jean's husband. Baby Caroline wore the same christening gown her mother had worn twenty-eight years earlier.

"For Jackie, being a mother seemed to validate her sense of self," family friend Doris Kearns Goodwin recalled. "It gave her an inner peace and security which nothing else ever had. It opened her heart."

Senator and Mrs. Kennedy ride in South Boston's St. Patrick's Day parade on March 17, 1958. Jack had just begun his campaign for reelection, and it was vital to his 1960 presidential hopes that he not only win but rack up an impressive victory margin. Jackie was about to get her first taste of rough-and-tumble campaigning.

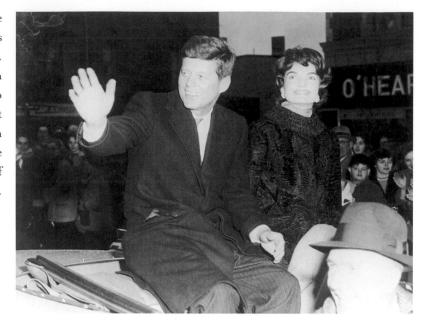

By now Jack Kennedy was a beloved figure in his home state. Large, adoring crowds surged to meet the senator and his wife wherever they went, and Bay Staters were mightily impressed with Jackie. Jack recalled that she was "simply invaluable" to his campaign. "In French-speaking areas of the state, she is able to converse easily with them, and everyone seems to like her. She never complains about the rugged schedule, but seems to enjoy it."

On October 5, eight-year-old Andrew Kelly of Grafton, Massachusetts, offered Mrs. Kennedy a chocolate ice cream cone to go along with her roses during a campaign stop. Moments like these were her favorite aspects of the campaign.

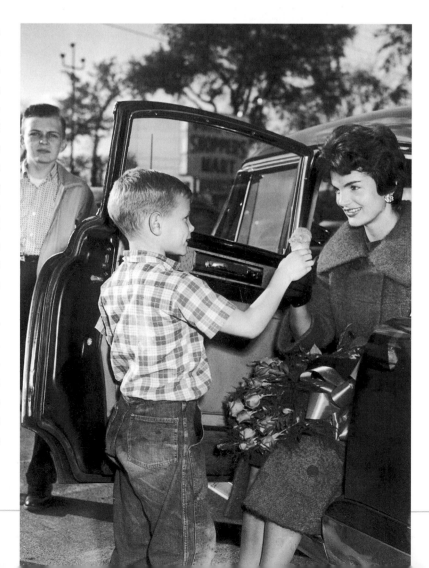

Jack, Bobby, Caroline, and other family members sail with Jackie off Hyannis Port in August of 1959. The senator had been reelected overwhelmingly, and a behind-the-scenes presidential effort had begun. Jackie worried about the effects of a national campaign on the baby. "All those books on child psychology—and I'm the type to read all of them— talk about how things affect children Caroline's age. I get this terrible feeling that when we leave [to campaign], she might think that it's because we don't want to be with her."

Jackie felt that Jack's presidential aspirations were premature. "We should be enjoying our family, traveling, having fun," she complained.

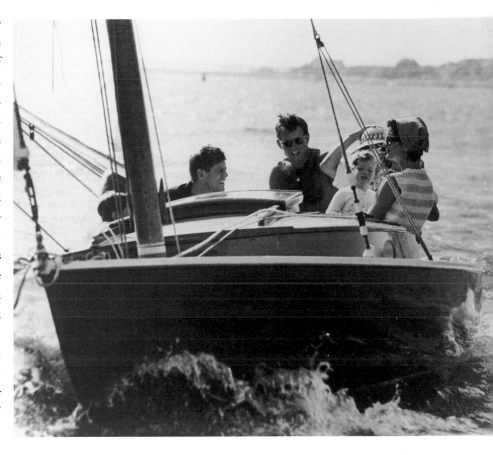

Jackie enjoys bubbly, blond, year-and-a-half-old Caroline during a vacation at the Kennedy compound in August 1959. She doted on the child, as did Jack. "He is so affectionate with his daughter," she said. "She has made him so much happier. A man without a child is incomplete."

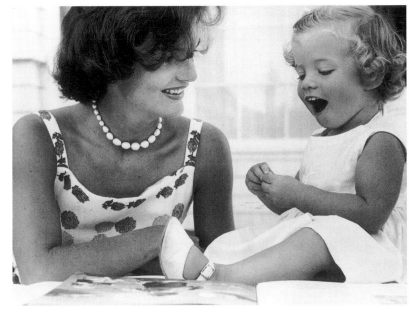

On January 2, 1960, Jack announced his candidacy. Four days later Jackie appeared with him at the annual Women's National Press Club welcome-to-Congress party in Washington. The main feature of the gathering was the congressmen's straw vote for their parties' national tickets. This year, Democrats chose Senator Lyndon Johnson of Texas for president and Jack for vice president.

Most political power brokers felt that Jack, at forty-two, was too young to be president, and that his religion would be an insurmountable obstacle—America had never had a Catholic president.

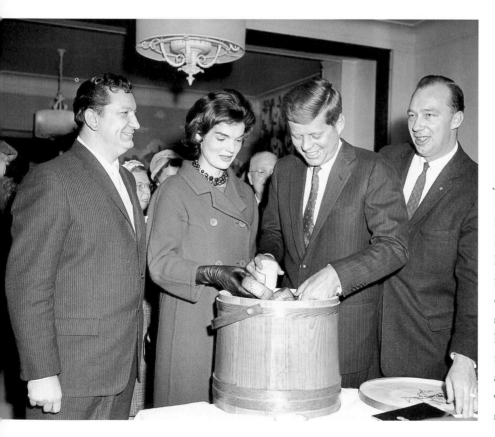

Jack easily won the primary in New Hampshire that February. The next, in Wisconsin, would be more difficult. He campaigned tirelessly, and when he had to rush back to Washington for a civil-rights vote, Jackie took over for him. She crisscrossed the state, visiting farms and attending luncheons. At one point she commandeered a supermarket public address system and in her breathy, well-modulated voice urged startled shoppers to vote for her husband.

Jackie smiles in approval as Jack scores a point during a debate in West Virginia on April 4. Jack had won Wisconsin, but not decisively enough to lessen concerns about his religion, since he had lost all of the state's predominantly Protestant precincts. The West Virginia vote became crucial because that state had only a small Catholic population. If Jack won there, he would finally put the religion issue to rest. He did, and his nomination for president became a virtual certainty.

After the primaries ended, the Kennedys announced that Jackie was pregnant. Jackie felt overjoyed. Jack wanted a large family, and they both hoped their second child would be a boy to complement two-and-a-half-year-old Caroline. Here, mother and child pose for photographer Eve Arnold in their Georgetown home shortly before the presidential nominating convention.

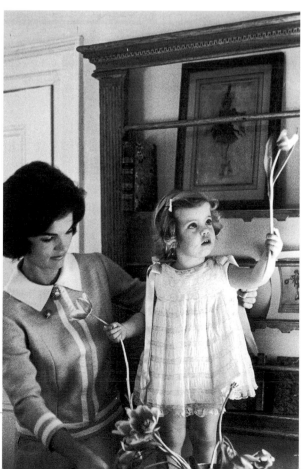

Jackie's pregnancy kept her away from the Democrats' gathering in Los Angeles; she didn't want a repeat of what had happened in 1956. On July 14, a day after Jack won the nomination and selected Lyndon Johnson as his running mate, Jackie expressed her delight at her husband's success to CBS radio reporter Dick Bates at the Kennedy home in Hyannis Port.

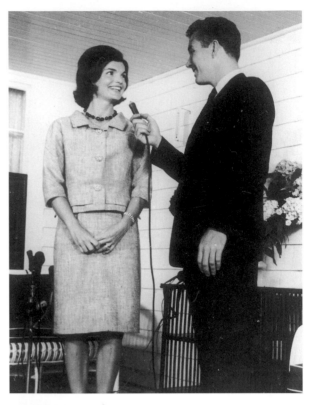

The Kennedy-Johnson campaign against Vice President Richard M. Nixon and his running mate, Henry Cabot Lodge (who had lost his Senate seat to Jack in 1952), proved to be a tough one. Jack's age and religion still counted against him among many voters; President Eisenhower's popularity and the strong American economy helped boost Nixon.

Jack needed Jackie's help. She made as many campaign appearances as she could, most of them close to their homes in Washington and New England. Here she addresses a group of volunteers in Virginia to kick off a "Calling for Kennedy" phone-bank effort.

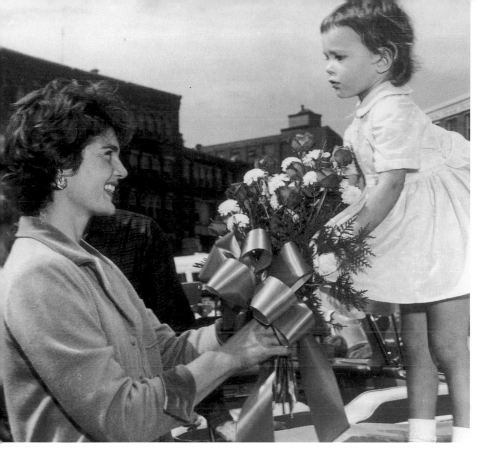

"Jacqueline Kennedy," read the newspaper caption for this photo, "receives bouquet from small-fry admirer during presidential drive in New England." Reporters continually pressed for her views on issues. "I certainly would not express any views that were not my husband's," she said. But, she quickly added, "I tell him what I *think.*"

Few would have guessed that Jackie didn't enjoy campaigning. Jack's aide Ken O'Donnell recalled that Jackie would "shake hands and talk to people on one side of the sidewalk on the main street . . . while her husband worked the opposite side. He kept his eyes on her and often muttered to one of us, 'She's drawing more people than I am, as usual.'"

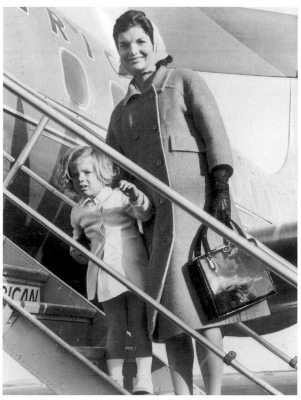

On October 2, Jackie and Caroline head back to Washington after a brief rest in Hyannis Port.

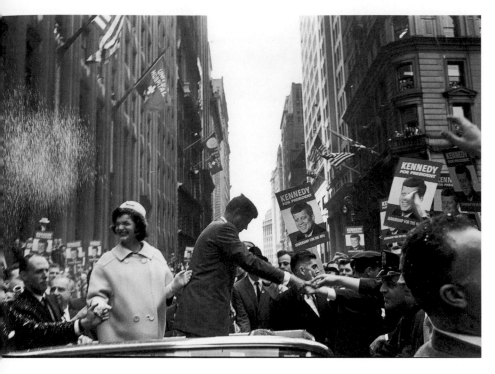

Later that month, the candidate and his wife are showered with confetti during a tumultuous ticker-tape parade through Manhattan's "Canyon of Heroes." Nearly three million people cheered and gawked; at one point the surging throng rocked the car so violently Jackie nearly fell out.

The Kennedy campaign brought out huge crowds everywhere, crowds that were dazzled by the attractiveness and youthful glamour of the Kennedys. But polls indicated that the race was too close to call. Jack had made a strong showing in his televised debates with Nixon, but doubts about his youth and experience lingered.

Less than a week before the November 8 election, Janet Auchincloss and her eight-months-pregnant daughter host a Democratic fund-raiser at Merrywood. The Auchinclosses were staunch Republicans, but Janet agreed to help Jack because, well, he *was* her son-in-law.

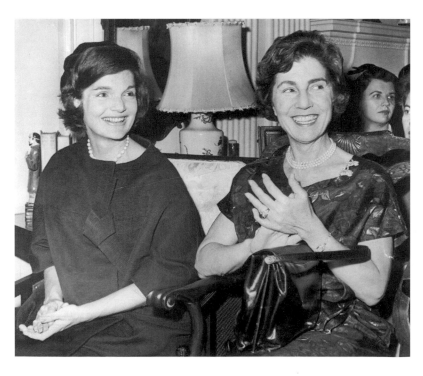

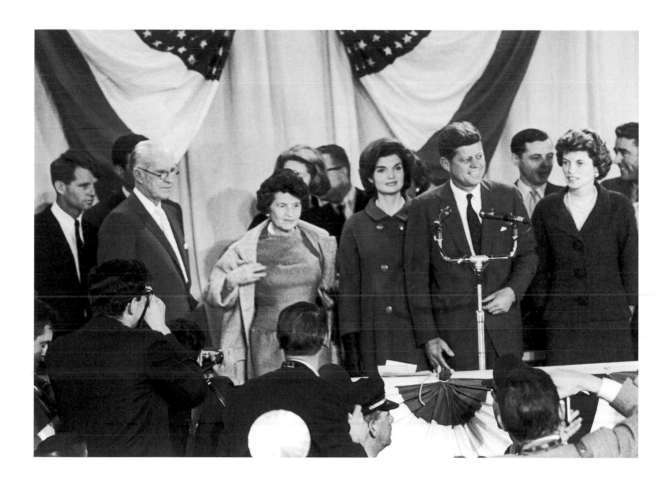

It wasn't certain until the early-morning hours of the next day, but, finally, John Fitzgerald Kennedy won election as the thirty-fourth president of the United States. After the results were clear, Jackie went for a long, solitary walk along the beach to contemplate what the future held for her. Later that day, at the Hyannis Armory, she and Jack, surrounded by his family, met the press. With them, left to right, are Bobby; Joe; Ted (blocked by his father); Rose; Ted's wife, Joan (partially obscured by Rose); Jean's husband, Steve Smith; Eunice Kennedy Shriver; and Pat's husband, Peter Lawford.

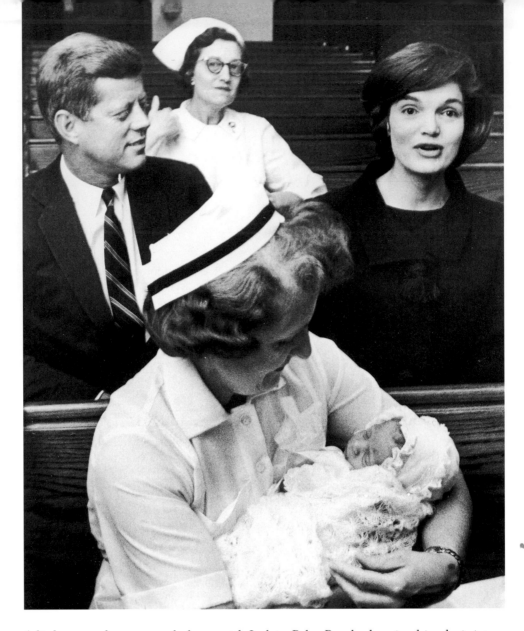

A little more than two weeks later, with Jack in Palm Beach planning his administration, Jackie gave birth prematurely to a baby boy at Georgetown Hospital. When Jack heard the news, he recalled he had been away when Jackie miscarried in 1955, and muttered, "I'm never there when she needs me." He rushed up to see her and met his son, John F. Kennedy Jr. "I'm so happy to have given Jack the son he longed for so much," Jackie said.

The baby was a little underweight and remained in an incubator for a week, but doctors proclaimed him healthy. On December 8, the son of America's next president was christened at the Georgetown University Hospital Chapel. Here, longtime Kennedy-family nurse Luella Hennessey holds him after the ceremony as his parents and a hospital nurse look on. John Jr. is dressed in his father's christening gown.

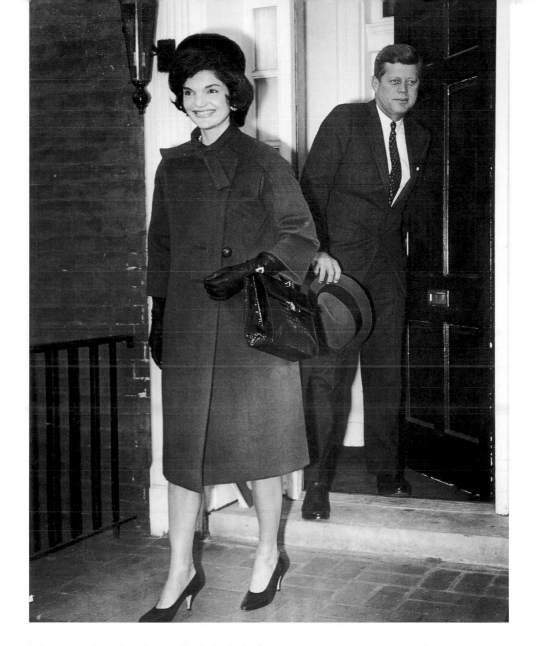

The next day, the Kennedys left their Georgetown home to rest and recuperate in Palm Beach. Jackie felt both anticipation and fear at Jack's impending presidency. She had gotten a taste of things to come when a photographer leaped out of a hospital storage closet to shoot her as she was being wheeled out of her room to visit her son in his incubator. "I felt as though I had turned into a piece of public property," she recalled. "It's really frightening to lose your anonymity at thirty-one." Still, she was buoyed by the tremendous potential and sense of hope that her husband's election represented for the country.

She was about to assume a position that only thirty-five women before her had held in American history, and she was determined to be a first lady who would truly make a difference.

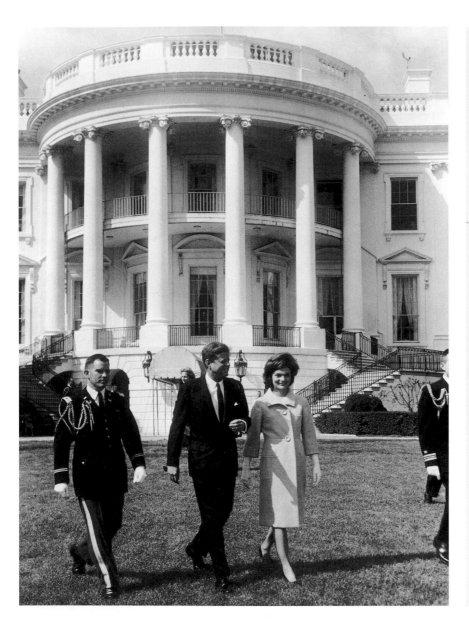

Marine guards escort President and Mrs. Kennedy to a reception on the south lawn of the White House, April 1962.

part three

First Lady

From moment one, America saw that this new first lady would be different. Most of the other women standing on the inaugural platform as John F. Kennedy was sworn in wore dark fur coats and the prim, flowery hats that had defined tasteful women's fashion for decades. Jackie stood out in her streamlined beige wool coat with huge round buttons, narrow fur collar, and matching pillbox hat over a bouffant hairdo. Instead of wearing white gloves, she carried a muff.

The new president's inspirational inaugural address made it clear that his administration's fresh ideas would lead the country boldly into the future. His wife made the same statement without words. Soon the "Jackie look" would sweep across the country.

She brought a gale of fresh air whistling through the musty old White House. Her love of art and design led her to renovate and redecorate the building (which she said reminded her of a cheap hotel) so that it would reflect the grandeur of its history. With her exquisite taste, she turned the president's home into a cultural center, made it sparkle and shimmer the way she and her husband often seemed to.

Her charm and her facility with foreign languages made her America's finest goodwill ambassador abroad—and her husband's best political ally at home. She became the Most Admired Woman in America, and held the position for nearly a decade.

With it all, she always maintained her first priority—to be a good wife and mother. She defended her husband, guarded her children's privacy, and fought to give her family as normal a personal life as possible. As her children grew into adults, it would become clear that she succeeded at that, too.

After her husband's death she told a journalist that one of his favorite recordings was the original cast album of the Broadway musical *Camelot*. "One brief shining moment" came to encapsulate the one thousand days of the Kennedy presidency. Jacqueline Kennedy had been a beacon in that glow, and America would never be quite the same after her.

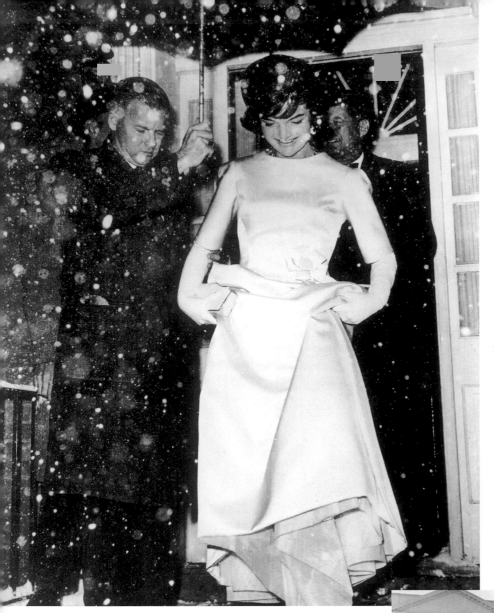

Through a snowstorm that left waist-high drifts in the Capital, President-elect and Mrs. Kennedy leave their Georgetown home to attend the preinaugural gala on January 19, 1961. The affair, which raised nearly $2 million and erased the Democrats' campaign debt, was produced by Frank Sinatra and Peter Lawford, and featured a glittering array of stars that included Ethel Merman, Laurence Olivier, Mahalia Jackson, Bette Davis, and Ella Fitzgerald. After Sinatra sang the ballad "The House I Live In," Jackie dabbed tears from her eyes.

The first lady walks to her new home after viewing the inaugural parade on January 20. Her husband's soaring address, one of the great speeches in American history, had deeply impressed her. "I was so proud of Jack. There was so much I wanted to say! But I could scarcely embrace him in front of all those people. So I remember I just put my hand on his cheek and said 'Jack, you were so wonderful!'"

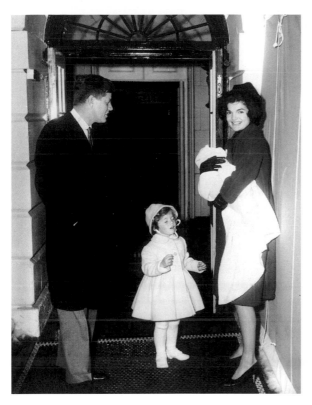

On February 4, Caroline, three, and her ten-week-old brother, John Jr., arrive at the White House for the first time. The children had remained at the Kennedy home in Palm Beach while their parents acclimated themselves to a new home and a new administration.

For a CBS television special on the National Gallery of Art on March 18, Jackie spoke from the White House about her first visit to the museum when she was twelve and the impression it had made on her. "It was then that I discovered one of my greatest delights—the deep pleasure experienced in looking at masterpieces of painting and sculpture."

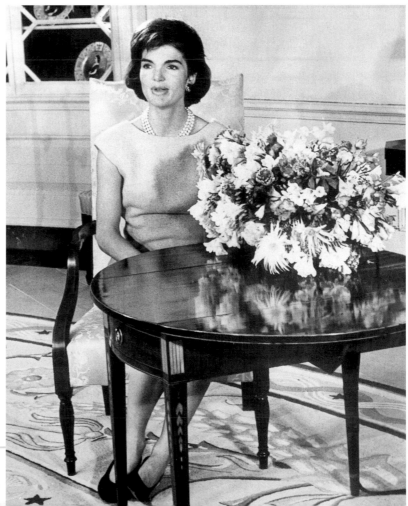

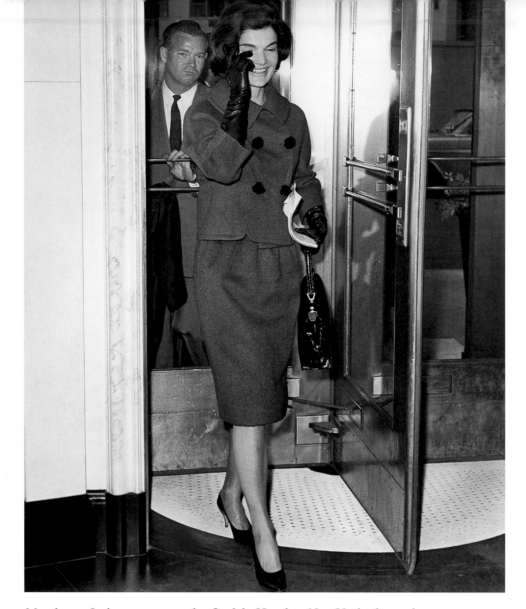

March 20: Jackie returns to the Carlyle Hotel in New York after a shopping tour to
find nineteenth-century antiques for her planned restoration of the White House.
Mamie Eisenhower had given Jackie a tour of the building after the election, and she
was appalled by its condition. "Oh, God," she said privately. "It's the worst place in
the world. . . . It looks like it's furnished by discount stores. . . . There's no trace
of the past. . . . I hate it, hate it, hate it!"

She set out to transform the house into a virtual museum of American history.
She wrote to the children and grandchildren of earlier presidents to ask what they
remembered of it, and she researched its interior decoration all the way back to
George Washington. She established fund-raising committees, designed a guide-
book to be sold to tourists for a dollar to raise additional funds, lobbied private col-
lectors to donate items that had originally been in the house, and scoured the
antique shops in New York to find just the right pieces she needed for every room.

The Kennedys are driven to reception ceremonies on the occasion of the Tunisian president's official state visit, May 3, 1961. Many of Jackie's duties as first lady were ceremonial, and she handled the often-tiring receptions with aplomb. She never failed to charm visiting dignitaries, a fact certainly not missed by her husband. "She's the best ambassador we've got," Jack said.

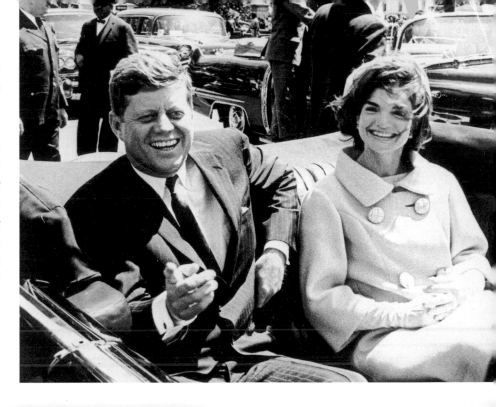

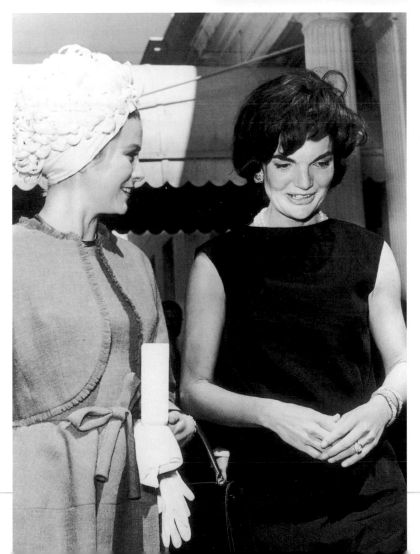

Jackie welcomes Princess Grace of Monaco to the White House on May 24, 1961. Both had appeared on the list of the ten women most admired by Americans in 1961; for most of the following decade, Jackie topped the list. The Kennedy family had known the former Grace Kelly for several years. When Jack was hospitalized for his back problem in 1954, Jackie had conspired to sneak Grace, then a movie star, into his room disguised as a nurse. The ploy, as they both had hoped, boosted his spirits.

47

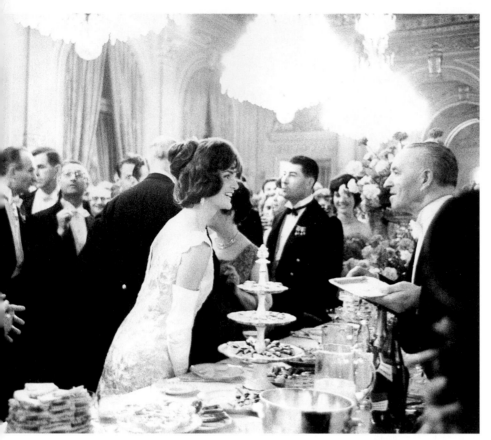

"I am the man," President Kennedy quipped, "who accompanied Jacqueline Kennedy to Paris." During the couple's state visit at the beginning of June, the French went gaga over the sophisticated, stylish American first lady, who had been introduced to them a few weeks earlier with a White House tour she conducted entirely in French. "I love France," she told them.

By the time the Kennedys arrived, the country was in a Jackie swivet. Rather than crying "Vive l'Amerique," Parisians chanted, "Jac-leen! Jac-leen!" wherever the first couple went. In this photo, taken at a reception at the Elysée Palace in Paris, Jackie seems to glitter as much as the crystal chandeliers.

The next night, French President Charles de Gaulle escorts Jackie into a state dinner at the Palace of Versailles. She disarmed the crusty de Gaulle by acting as interpreter between him and her husband. "She played the game very intelligently," de Gaulle said. "Without mixing in politics, she gave her husband the prestige of a Maecenas [the ancient Roman statesman and art patron]."

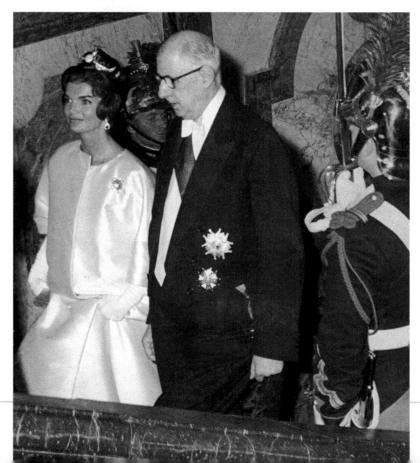

Jackie meets Soviet Premier Nikita Khruschev in Vienna on June 4, 1961. Relations between the United States and Russia had soured dramatically since Cuba turned Communist in 1959, and President Kennedy hoped a summit with Khruschev would help ease tensions.

Khruschev proved as susceptible to Jackie's appeal as most other men. The night they met he began to proselytize to her about the superiority of Soviet education. "Oh, Mr. Chairman," Jackie said with a smile. "Don't bore me with statistics."

Khruschev didn't mind the rebuff. "I liked her very much," he said. "She was, as our people say, quick with her tongue. In other words, she had no trouble finding the right word to cut you short if you weren't careful with her. . . . Even in small talk she demonstrated her intelligence."

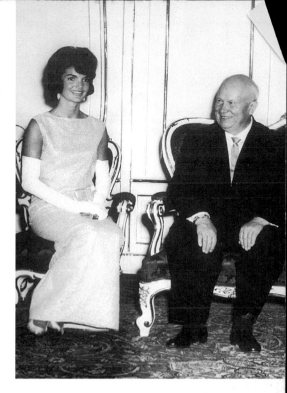

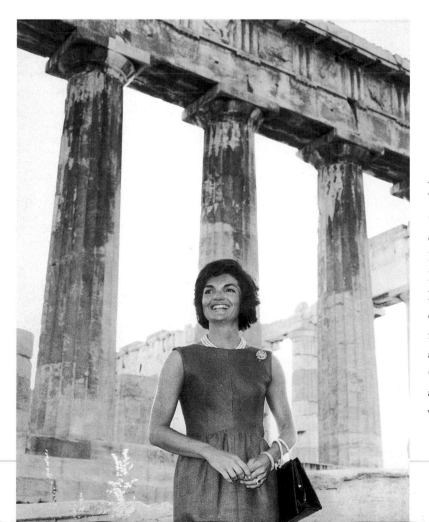

After the president returned to Washington, Jackie went on to Greece, where she was the guest of Greek Premier Constantine Karamanlis. Here she visits the Parthenon, the fourteen-hundred-year-old Doric temple on the Acropolis in Athens. She found the country "enchanting" and added, "Everyone should see Greece. . . . My dream is to have a house here to spend vacations with my children."

49

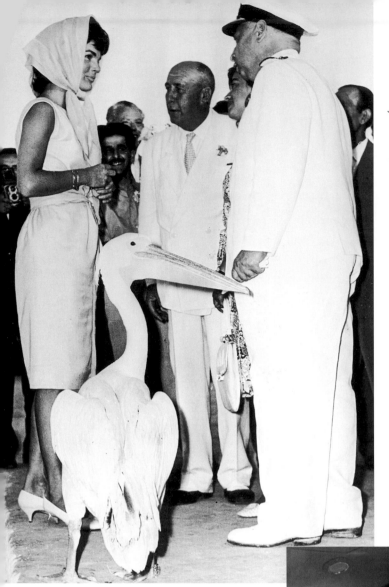

On Mykonos on June 13, Port Officer Captain Stambolis tells Jackie all about "Peter," the island's pelican mascot. Jackie's trip included visits to Apollo's birthplace on the island of Delos and the ruins of the Temple of Poseidon and Hydra, where she danced the Kalamatianos.

Jackie seems eager to tell the president about her Greek adventures as he picks her up at Washington's National Airport on June 15. He had aggravated his back problem planting a tree in Canada the week before, and was in too much pain to get out of the car to greet her.

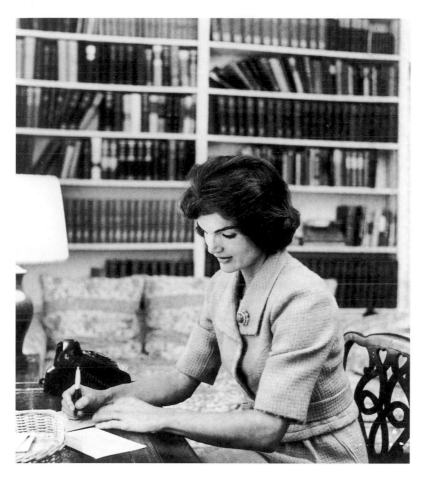

At her desk in the family's private living quarters, Jackie, an inveterate letter writer, pens one of the dozens of thank-you notes, solicitations for donations for her White House renovation, and other correspondence she sent out each week. All handwritten, the letters often charmed the most hard-bitten heads of state and persuaded reluctant collectors to part with their treasures.

Jackie rushes past photographers at La Guardia Airport's Marine Air Terminal in New York on September 25. She had flown from Cape Cod aboard the family's private plane, *Caroline,* to hear her husband's address to the United Nations General Assembly.

October 27: At the International Horse Show in D.C.'s National Guard Armory, the first lady awards a trophy to Carlos Damm Jr. Horse Show president Harvey M. Spears looks on.

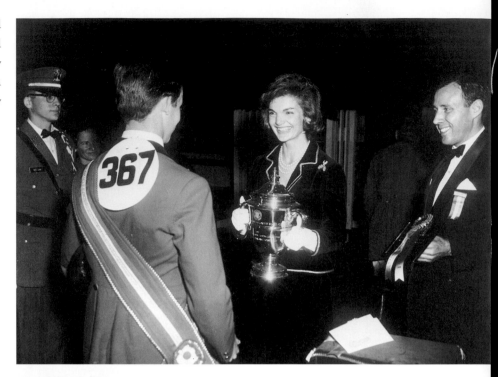

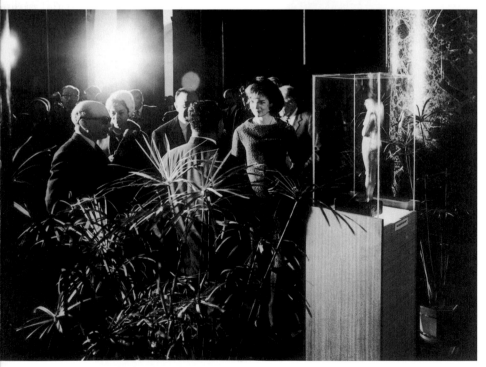

Jackie takes a tour of the Tutankhamen exhibit at the National Gallery on November 3.

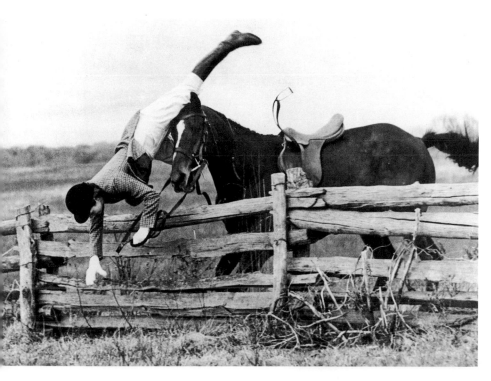

Later in the month, Jackie took a graceful spill off her bay gelding, Bit Irish, during a fox hunt on the estate of philanthropist Paul Mellon in Virginia. The horse refused to jump the fence and sent Jackie tumbling. She hit the ground, rolled on the lush grass, and then jumped up and flashed a chagrined smile at photographer Marshall Hawkins. Reluctant to embarrass the first lady, Hawkins asked her permission to publish his photos of the accident. She consented.

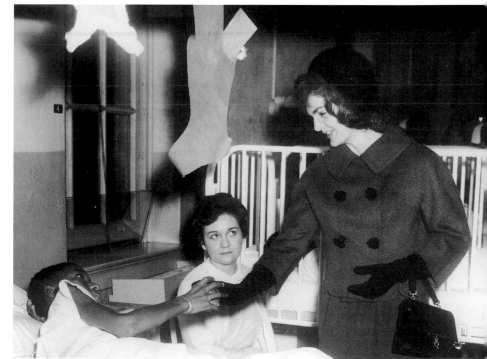

A patient at D.C.'s Children's Hospital receives a small Christmas gift from Mrs. Kennedy as she tours the facility on December 12, 1961.

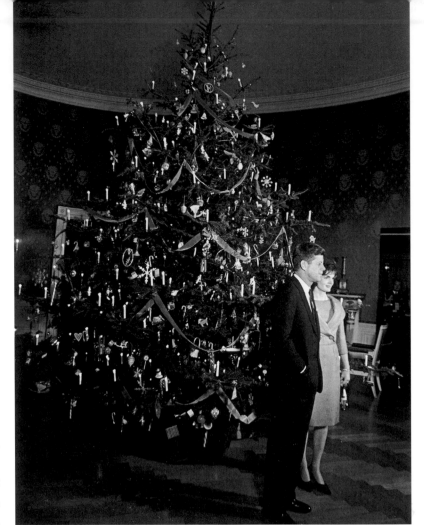

Three days later, the president and first lady pose in front of the White House Christmas tree shortly after its ceremonial lighting in the Blue Room.

The next day (below), Jack and Jackie greet guests at a reception in the home of San Juan's governor, Luis Muñoz Marín, during a goodwill trip to Puerto Rico, Venezuela, and Colombia. America's relations with Latin American countries had become strained after the disastrous attempt by U.S. Marines to invade Cuba's Bay of Pigs in April, and JFK hoped the visit would mend some fences. Jackie proved a tremendous asset in that regard. She charmed her audiences by speaking to them in Spanish, and even won over a group of Communist students in Caracas, who held up signs that read, KENNEDY—NO, JACKIE—SI!

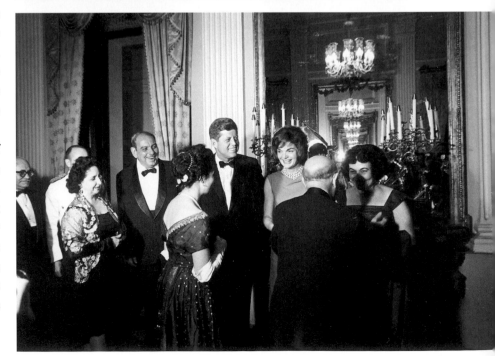

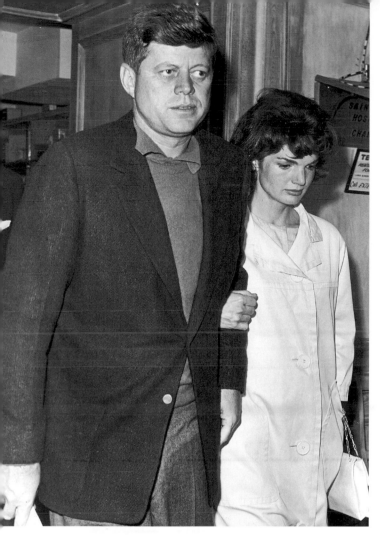

December 24: Concern etches their faces as the Kennedys leave St. Mary's Hospital in Palm Beach after a visit to his stricken father. Joe had suffered a massive stroke on the nineteenth and was hooked up to life-support systems. On Christmas Eve doctors performed an emergency tracheotomy to relieve congestion in his throat and chest caused by pneumonia. "He was one breath away," family friend Lem Billings said, and for a time the family considered turning off the support.

Joseph Kennedy survived eight more years, but the once-vibrant patriarch remained paralyzed and incapacitated for the rest of his life.

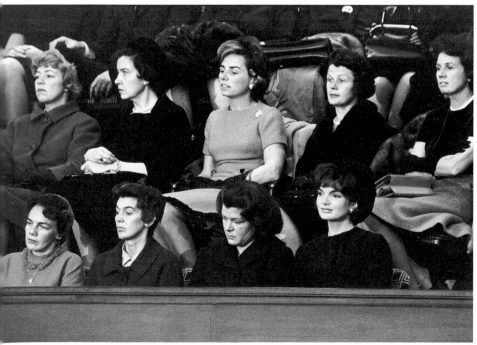

Jackie and her sister-in-law Ethel join other dignitaries' wives in the gallery as JFK delivers his second State of the Union Address to a joint session of Congress on January 11, 1962.

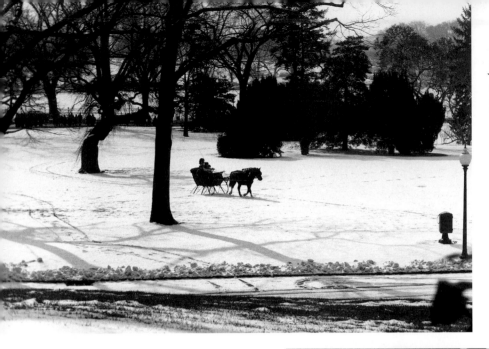

Jackie takes Caroline and John for a sleigh ride across the White House grounds on February 13.

The next day CBS television presented "A Tour of the White House with Mrs. John F. Kennedy," a one-hour special hosted by Charles Collingwood. Her restoration of the mansion was complete, and Jackie was eager to show off its glorious new look and all the antique furniture and paintings she had added, many of which had once been in the house. "She really knew her stuff," Collingwood said later. "She didn't worry about her makeup or 'best' camera angles. When the director gave her instructions, she followed them exactly. . . . If she was tired, she didn't complain or show it."

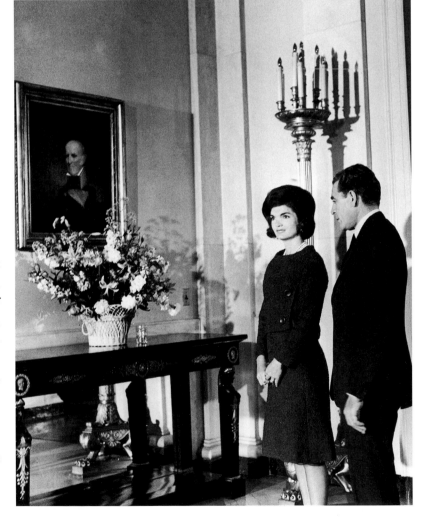

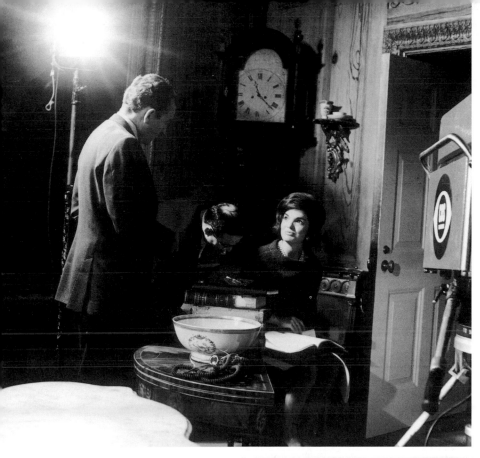

During the taping, Jackie goes over the script with Collingwood and writer/producer Perry Wolff. The special, a ratings blockbuster that won Jackie an Emmy, gave the country its first full-scale, intimate look at its first lady. Her reviews were mixed. Many viewers found her charming, but others thought she seemed stiff and somewhat vacant. Some mocked her whispery voice, which they compared to Marilyn Monroe's in her dumb-blonde perform-ances.

In March, Jackie traveled to Italy, India, Pakistan, and England on her first solo trip abroad as first lady. Here, she is shown in Rome, arriving in a U.S. Embassy car for a dinner in her honor at the palace of Count Dino Pecci-Blunt, an old family friend.

Wearing a black lace mantilla she borrowed from Ethel, Jackie has an audience with Pope John XXIII on March 12. With them, left to right, are Monsignor Pio Penincasa of Buffalo, Monsignor Paul Marcinkus of Chicago, and Archbishop Martin O'Connor of Scranton, Pennsylvania. The Pontiff and the first lady conversed in French for half an hour, and she presented him with a book of JFK's speeches. Later she said that she had seen "centuries of kindness" in the Pope's eyes.

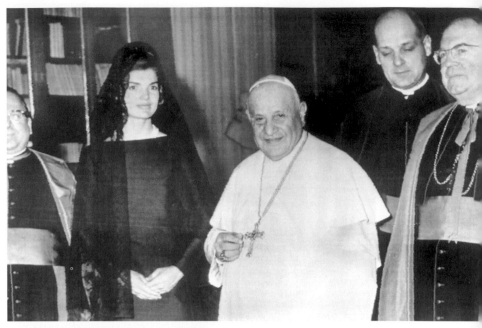

Jackie seems wary of Indian Prime Minister Nehru's intentions as he greets her upon her arrival in New Delhi. She confided to one of her traveling companions that she was nervous about making an official trip abroad without her husband, but the people of India embraced her. She visited the Taj Mahal, floated down the Ganges on a boat canopied with thousands of marigolds, and ate wild boar.

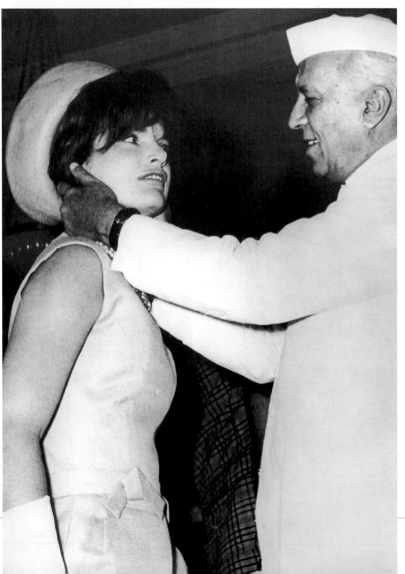

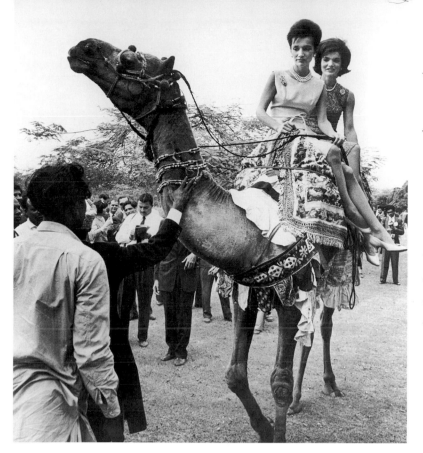

Jackie's sister Lee, now married to Prince Stanislas Radziwill, looks uncomfortable as she and Jackie sit atop a camel in New Delhi. After Indira Gandhi taught Jackie the *namaste,* the traditional Indian greeting of a slight bow with hands placed together as if to pray, Jackie performed it while she stood in the backseat of an open car—eliciting wild cheers from the throngs along the roadway. "Jackie Ki Jai! Ameriki Rani!" they roared— "Hail Jackie! Queen of America!"

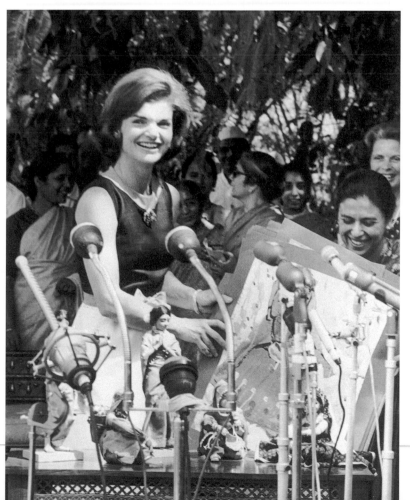

Jackie inspects some folk paintings in a New Delhi bazaar on March 14. The Indian people showered her with gifts, including a rare carpet, a baby elephant, and a pair of tiger cubs. The animals wound up in American zoos. She gave the other gifts to charity, with two exceptions presented to her by the president of Pakistan: a thoroughbred bay gelding named Sadar, and a necklace of diamonds, rubies, and emeralds.

In England for a three-day stay before her return to the United States, Jackie poses with Lee in the doorway of the Radziwill home on Buckingham Place in London. Jackie and her sister sometimes found themselves in competition with each other. When Jackie read a newspaper item that called Lee the "more elegant" of the two, she wrote to a friend in Paris asking to be informed about the "prettiest things" in the spring collections before Lee beat her to them.

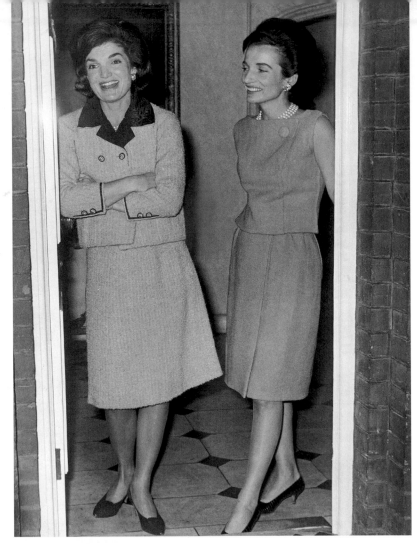

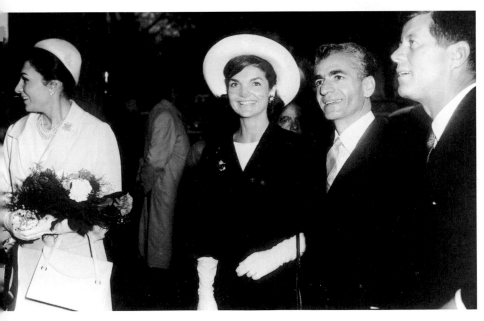

Back in Washington on April 11, Jackie joins the president in welcoming the Shah of Iran to the White House. The Shah's secular government maintained good relations with the United States until the revolution of 1979, when the Shah was deposed and the Ayatollah Khomeini came to power.

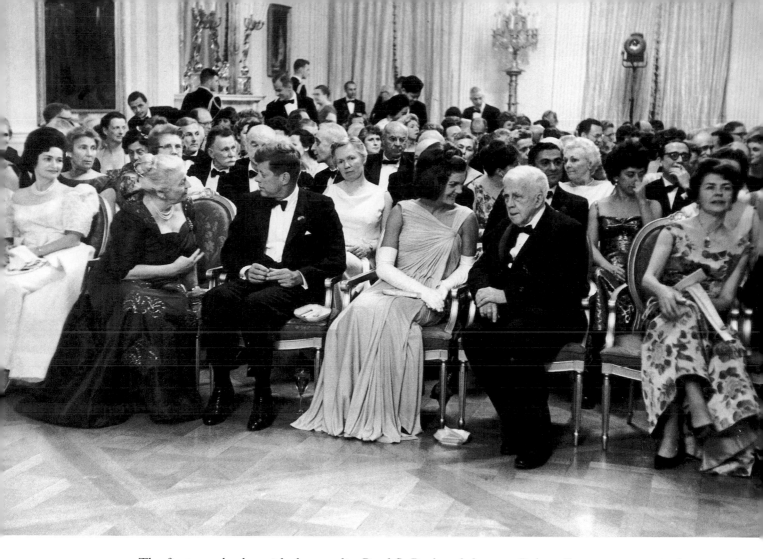

The first couple chat with the novelist Pearl S. Buck and the poet Robert Frost at a White House reception and dinner for forty-nine Nobel Prize winners on April 29, 1962. Jackie worked to bring the finest in cultural events to Washington. Ballets, drama and poetry readings, and musical recitals became a regular part of the White House social calendar.

At this event, the novelist William Styron recalled, "Jack and Jackie actually shimmered. They were truly a golden couple." Before dinner the actor Fredric March read from the works of three Nobel laureates, and then the president spoke. "This is the most extraordinary collection of talent, of human knowledge, that has ever gathered in the White House," he said. "With the possible exception of when Thomas Jefferson dined alone."

May 1: Lady Bird Johnson escorts Mrs. Kennedy into the Old Supreme Court Chamber for a luncheon in her honor given by the Senate wives to benefit the Red Cross.

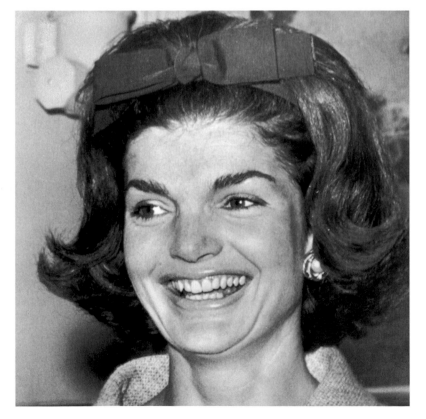

At another reception in her honor two days later, Jackie causes a sensation with a new flip hairdo topped off with a large bow. The first lady's new look made news across the country, which puzzled her. "Why are people so interested in what I wear and how I fix my hair?" she asked a friend. "What they should be interested in is what Jack's doing."

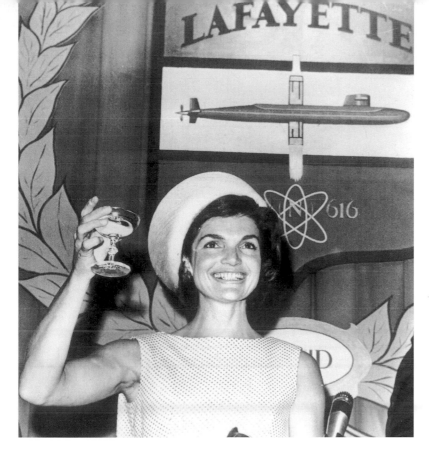

"Vive la *Lafayette!*" Jackie toasts the Navy's new Polaris submarine at a luncheon in Groton, Connecticut, on May 9. She had just christened the seven-thousand-ton vessel.

Jackie patiently waits her turn to address a gathering of Democratic women in Washington on May 22. Behind her are, left to right, Senator George Smathers of Florida, Senate Majority Leader Mike Mansfield, Hubert Humphrey, Vice President Johnson, and an unidentified woman.

Three days earlier, Jackie had stayed away from a star-studded birthday celebration for the president in New York's Madison Square Garden, which was attended by most of the Kennedy family. Plausible excuses were made for her absence, but the real reason Jackie wasn't there was

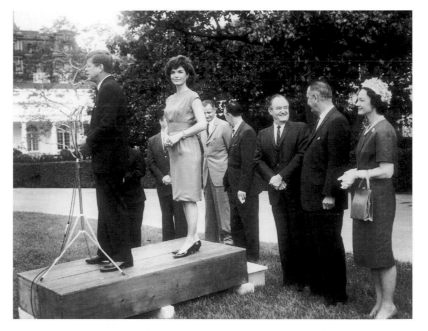

that Marilyn Monroe was scheduled to sing "Happy Birthday" to Jack at the event. Jackie knew that the president and Monroe had

been involved sexually for several years.

Jackie proves distracting to two young spectators as she watches four-and-a-half-year-old Caroline compete in the Apple Barrel Pony Rally at Halfway, Virginia, on June 13, 1962. Riding her pony, Macaroni, Caroline won a silver pin and a blue ribbon and proved herself a fine young equestrian, just as her mother had been at the same age.

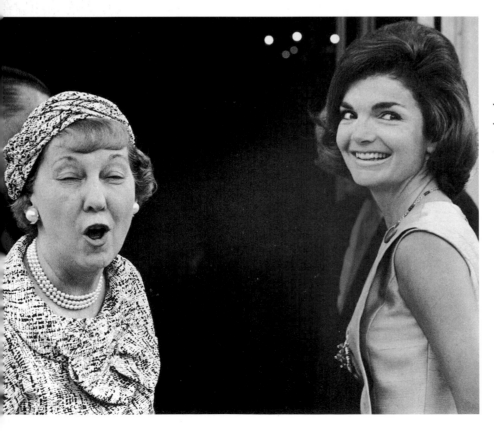

June 28: A study in contrasts, Jackie and Mamie Eisenhower speak to the press outside the White House before a luncheon for the benefit of the proposed National Cultural Center. The first lady and her predecessor were to serve as co-chairs of the fund-raising committee for the Center (later the Kennedy Center for the Performing Arts), which President Eisenhower had signed into law. But Mamie took only a figurehead role and complained to friends that there was no way she could avoid a subordinate role to Mrs. Kennedy.

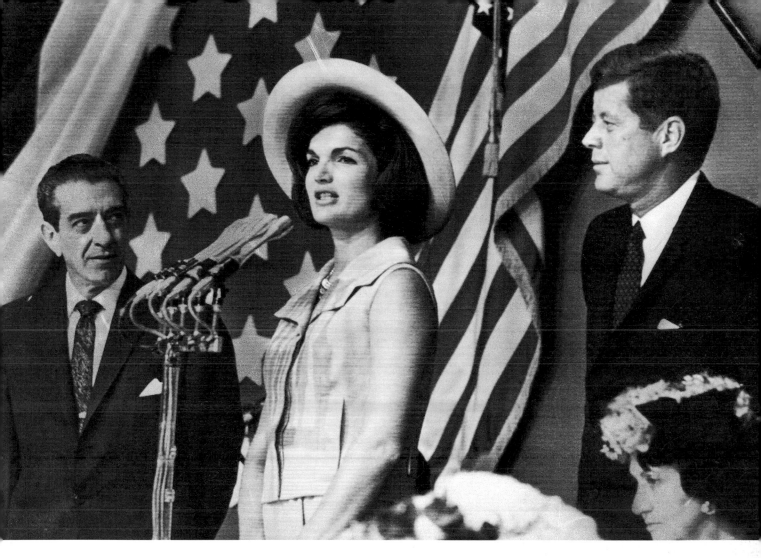

Jackie charms yet another country as she speaks in Spanish to a crowd in Mexico City on June 30. She praised the Mexican government's efforts to improve the lives of its citizens as JFK and Mexican President Lopez Mateos looked on.

The burden of the first couple's often crushing schedule was relieved by the ministrations of Dr. Max Jacobson, who earned the nickname "Dr. Feelgood" with a vitamin injection that rejuvenated his most overworked patients. Later it was learned that the injections contained amphetamines, which when misused can cause addiction and a variety of neurological problems, including disorientation and depression. The president received about four shots a week; Jackie needed fewer. Neither seemed to have been adversely affected. They swore by Jacobson's "miracle cure" and recommended it to friends and family.

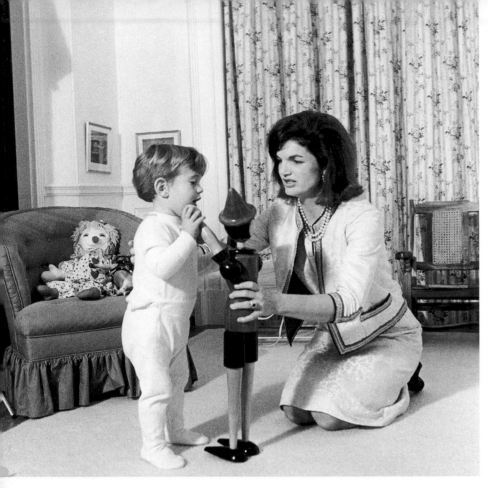

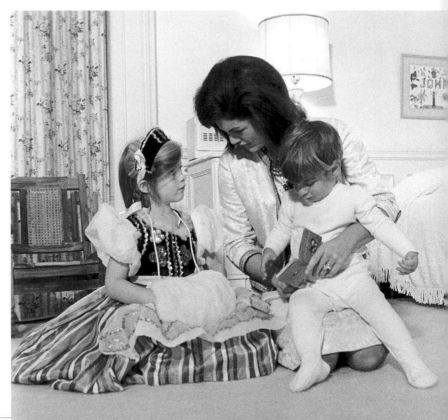

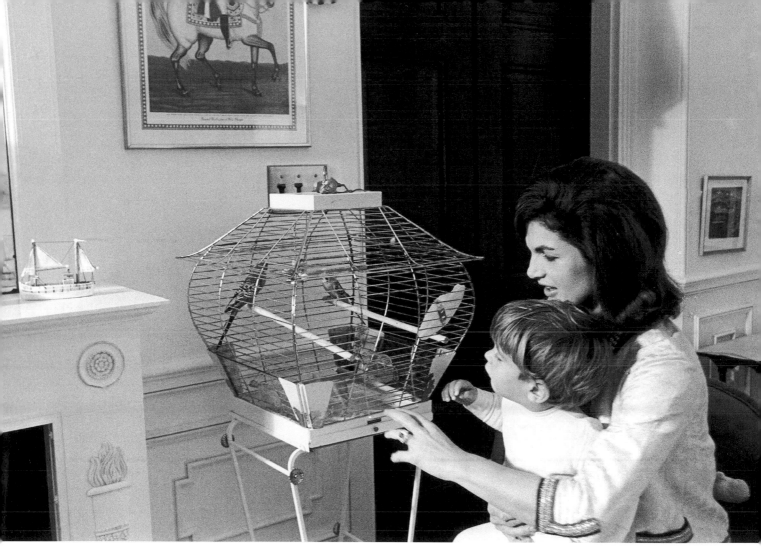

Jackie always tried to spend as much time with the children as possible, but her schedule rarely allowed as much as she wanted. Summers, when the activities of official Washington lessened, offered her the best opportunities to mother Caroline and John. In these photos, taken the first week of August in the White House nursery, official photographer Cecil Stoughton captures Jackie introducing John to a Pinocchio puppet; reading to him and Caroline, who wears a ceremonial costume her mother brought back from one of her foreign trips; and telling John all about the family's pet parakeets.

Jackie worried about raising her children to be normal adults in the rarefied fishbowl atmosphere of their lives. "I think it's hard enough to bring up children anyway, and everyone knows that limelight is the worst thing for them. They either get conceited, or they get hurt. . . . They need their mother's affection and guidance and long periods of time alone with her. That's what gives them security in an often confusing new world."

She was strict with the children, but never talked down to them. "I want John and Caroline to grow up to be good people," she told a friend.

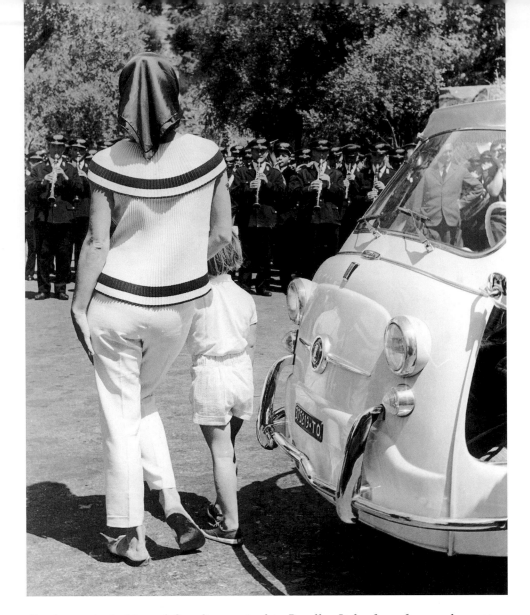

On August 7, Jackie and Caroline arrived in Ravello, Italy, for a five-week vacation as guests of the Radziwills. Before she left the United States, Jackie was asked to comment on the apparent suicide of Marilyn Monroe two days earlier. She was not ungracious. "She will go on eternally," Jackie said.

In Ravello, Jackie and Caroline stayed in an eleventh-century villa high on a cliff overlooking the city's beautiful bay. Security was high, both to ensure their safety and to protect them from the swarms of paparazzi who seemed to be everywhere.

Mother and daughter sailed to Capri on a yacht, played on the beach, toured Ravello's ancient cathedral, and took shopping trips. In these photos, Jackie and Caroline are serenaded by an Italian band; Jackie helps Caroline with her spaghetti after teaching her to water-ski; and Jackie's nephew Anthony Radziwill joins her and Caroline—dressed as a tarantella dancer—as they attend a song-and-dance festival in the Ravello town square on August 28.

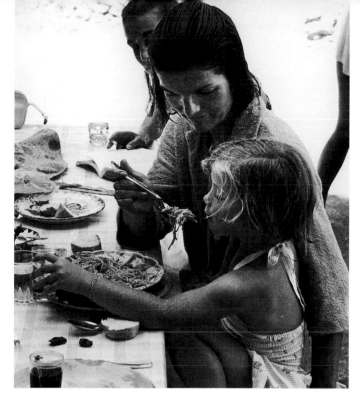

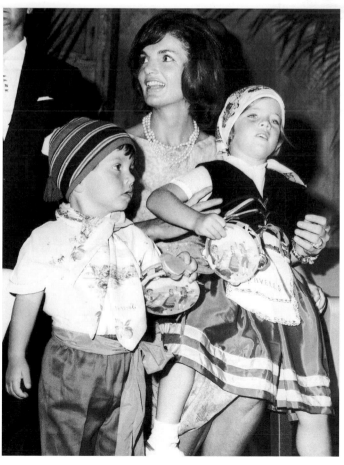

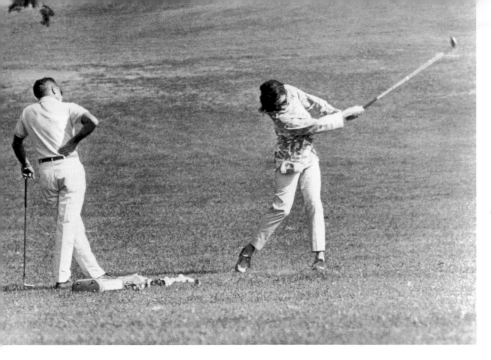

September 13: Back from Italy but still vacationing, Jackie takes lessons from golf pro Henry Lidner at the Newport Country Club near Hammersmith Farm. She took the lessons in order to share the golfing experience with JFK, but she never developed much of an aptitude for the sport, and Jack's playing time was limited by his back pain.

A week later, the first couple take in the fourth annual Americas Cup race in the bay off Newport. They are aboard the *U.S.S. Joseph P. Kennedy Jr.*, named after Jack's older brother, who was killed in World War II.

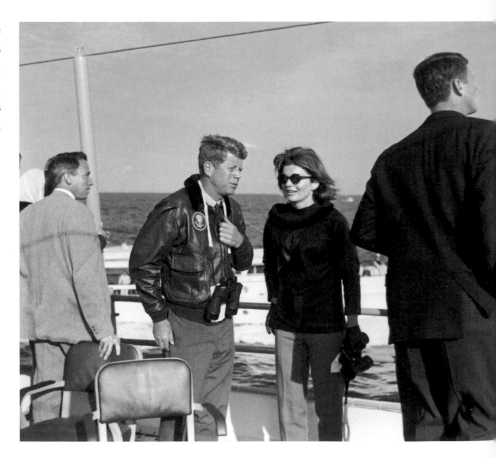

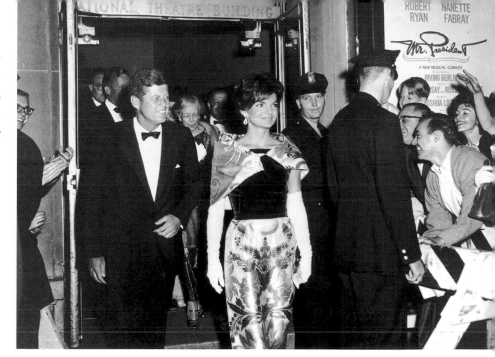

Back in Washington on September 25, Jack and Jackie take in an appropriate new show—*Mr. President,* a musical comedy by Irving Berlin.

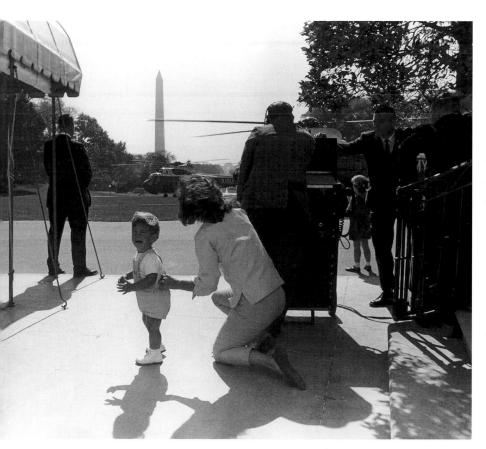

October 11: Jackie attempts to calm John as he bursts into tears watching his father's helicopter leave the lawn of the White House. JFK delighted in his son, whom he loved to make laugh and regaled with stories of the White Whale, an imaginary fish that would always follow the family yacht when they went on sailing trips. Their closeness made separation from his father difficult for the boy. When the president had to leave him to go to work in the morning, John would usually make such a fuss that Jack simply brought him to the Oval Office and let him play on the floor.

71

Worry is apparent on their faces as President and Mrs. Kennedy leave St. Stephen's Church in Washington after attending Mass on October 21. The president had reportedly canceled a weekend trip because of a cold, but in fact he had just learned that the Soviet Union had stockpiled nuclear missiles in Cuba and that launch sites were under construction on the island, just seventy-five miles from the U.S. mainland.

The next night, the world was stunned when the president made a stern, frightening televised address in which he instituted a naval blockade of Cuba and warned that an attack on any country by the Soviet Union "will be considered an attack upon the United States, requiring a full retaliatory response." The very real prospect of a nuclear war terrified the world, but Soviet Premier

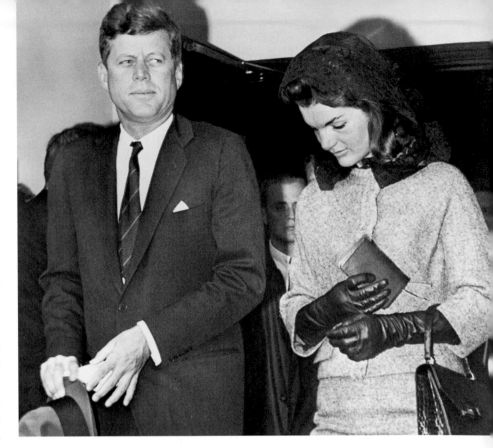

Khruschev, who thought he could take advantage of Kennedy's youth and interest in peace, backed down after thirteen tense days and agreed to remove the missiles from the island.

JFK's masterful handling of the Cuban Missile Crisis strengthened his hand as a world leader and caused his popularity, already high, to skyrocket.

A few days after the end of the missile crisis, Jack and Jackie attend funeral services for Eleanor Roosevelt in Hyde Park, New York. The widow of President Franklin Roosevelt, considered the most influential and activist of all first ladies, Eleanor had been slow to endorse Jack's candidacy, but eventually became a Kennedy supporter.

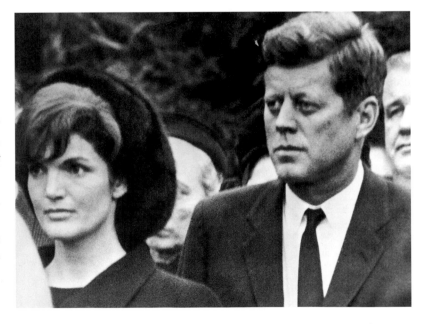

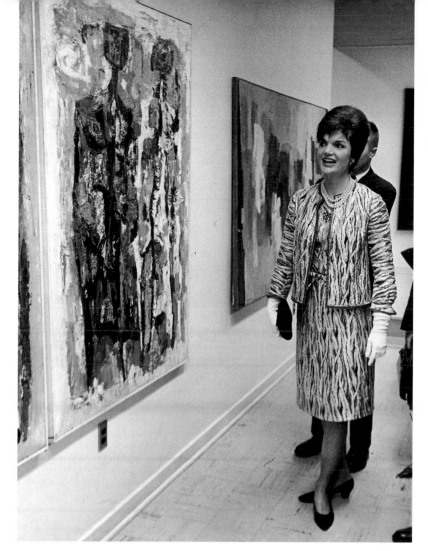

Jackie's outfit competes with the paintings as she attends the opening of a modern art exhibit at the Pan American Union in Washington on November 20. The exhibit featured works by Latin American artists. This one, by Raquel Ferner of Argentina, is entitled *Those Who Saw the Moon*.

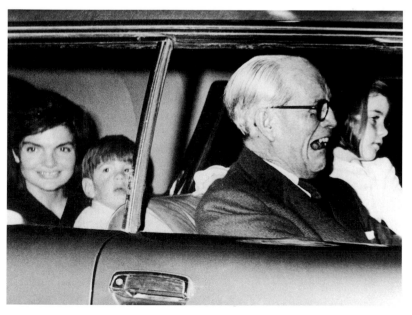

December 18: Caroline and John ride with their mother and grandfather to the Kennedy home in Palm Beach for the Christmas holidays. The effects of Joe Kennedy's stroke are apparent on his face.

On Christmas morning, the Kennedy and Radziwill families gather under the stockings for a holiday portrait. With them is Gustavos Parades, the son of Jackie's maid "Provi" Parades. The dogs are Clipper and Charlie.

Nineteen sixty-two had been an eventful, difficult, even dangerous year for the country, but John F. Kennedy had come through it with a stronger hold than ever on the American public's affection. With his hard-won experience, everyone expected 1963 to be the best year yet of his presidency.

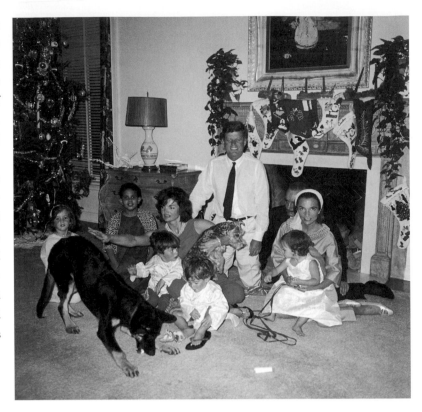

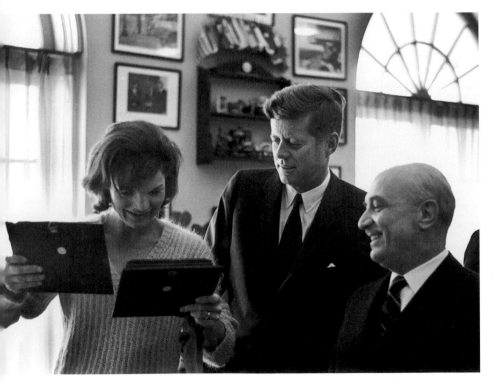

Jackie seems delighted by the miniature paintings presented to her and the president by a representative of the Italian government during a visit to the White House on January 17, 1963.

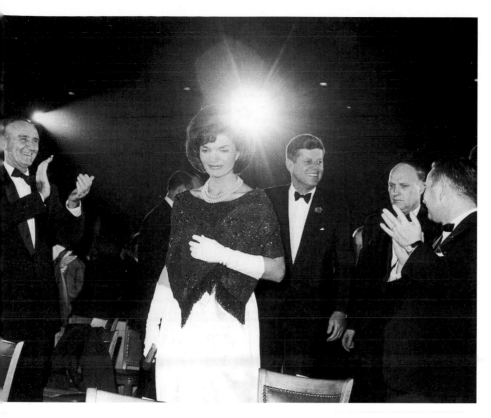

The first couple are in the spotlight at the National Guard Armory as they take their seats at a gala commemoration of the beginning of JFK's third year in office. With them, from left to right, are Mike Mansfield, Democratic National Chairman John Daly, and Rep. Carl Albert of Oklahoma.

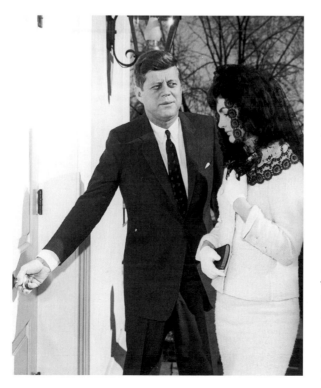

The president opens the door for his wife as they arrive at the Middleburg Virginia Community Center to attend Mass on February 13. The first family was spending the weekend at their nearby country estate, Glen Ora. To Jackie, the leased four-hundred-acre retreat was home. It provided a respite from the never-ending social whirl of Washington, with horses for Jackie and ponies and a play cave for the children.

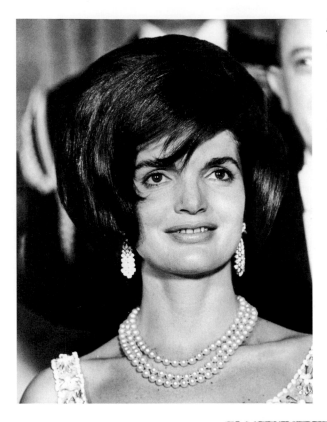

Jackie looks particularly glamorous at a White House reception in honor of King Hassan II of Morocco on March 27. Excerpts from the musical *Brigadoon* were performed after the state dinner.

At the presidential retreat Camp David the following weekend, Caroline sits proudly atop Macaroni while her brother seems eager to climb on next. On April 18, in Palm Beach, Jackie announced that she was pregnant. "It is such a happy thing," she wrote to a friend, and the country shared her joy at the prospect of the first baby born to an incumbent president.

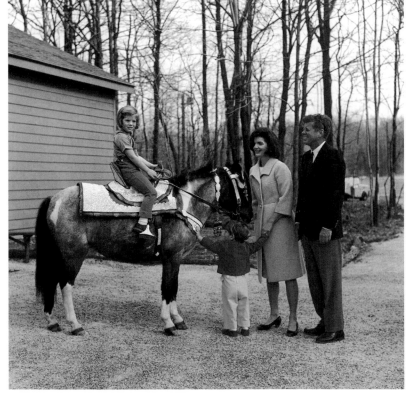

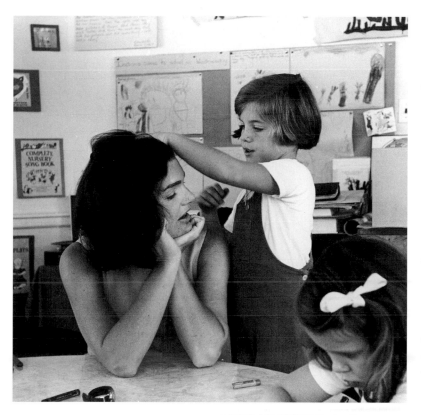

Caroline and some of the children of the president's staff attended a kindergarten that Jackie established in the third-floor White House solarium. She and the other mothers took turns as teachers, and the children's lessons often tied in to whatever the president was doing that day—if there was a ceremony, for example, they would watch it from the balcony. At one point Jackie brought in a pregnant rabbit so the children could watch the birthing and mothering process—something very much on Jackie's mind on May 24, when this picture was taken, since she was due in early September.

Unable to give up her heavy smoking habit even while pregnant, Jackie attempted to rest all she could to avoid any problems with her pregnancy. Here she relaxes aboard the presidential yacht, *Sequoia,* off Cape Cod in late July.

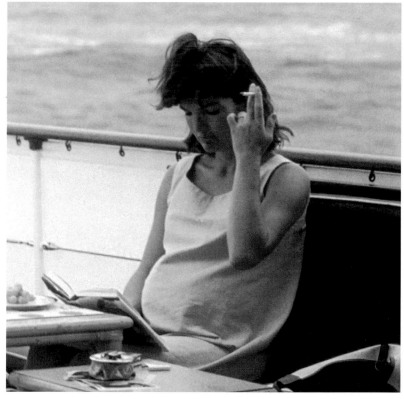

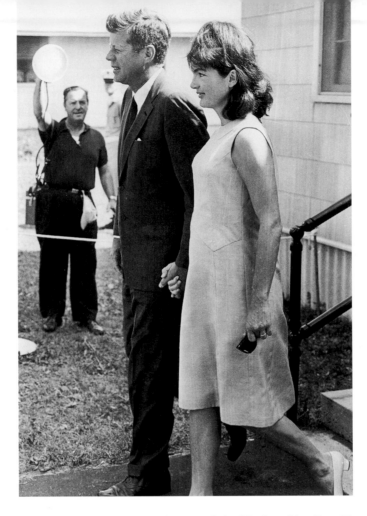

On August 5, 1963, President Kennedy signed the Nuclear Test Ban Treaty with the Soviet Union. His joy was short-lived, because two days later Jackie was rushed to the hospital with abdominal pains. On the way to Otis Air Force Base, she lost her customary composure. "You've just got to get me to the hospital on time!" she pleaded. "I don't want anything to happen to this baby!"

Just before one in the afternoon on August 7, Jackie gave birth to a four-pound, ten-ounce boy by cesarean section. The president arrived at the hospital forty-five minutes later to find the child in an incubator and suffering from a respiratory ailment. A base chaplain baptized the baby Patrick Bouvier; he was then flown to Boston for better care. Jack accompanied him and spent the night in a vacant hospital room.

America celebrated the birth but soon got the bad news that the baby had only a fifty-fifty chance to live. On August 9, just forty hours old, Patrick succumbed. The president wept after he heard the news, and when he and Jackie were reunited back at Otis Air Force Base, they sobbed together. "Oh, Jack," Jackie said to him. "There's only one thing I could not bear now—if I ever lost you."

On the fourteenth, Jackie was released from the hospital and walked hand-in-hand with the president to a waiting car, which took them to their vacation retreat on Squaw Island.

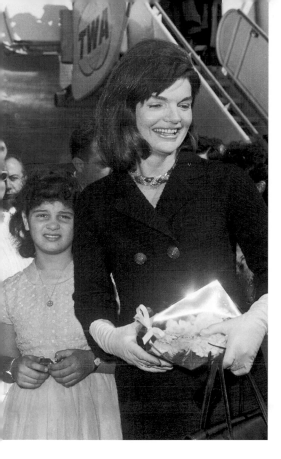

October 4, 1963: Jackie arrives at the Athens airport on her way to an island-hopping Aegean cruise aboard Aristotle Onassis's yacht *Christina.* Concerned about his wife's depression after baby Patrick's death, the president urged her to take a trip abroad after a seven-week recuperation. Some of his staff argued against the idea, since criticism had been leveled at the first lady for favoring foreign travel, and JFK would be up for reelection in a year. "We will cross that bridge when we come to it," Kennedy replied. "I want her to go on this trip. It will be good for her."

Jackie accepted the invitation from Onassis, an intimate friend of her sister's, and joined the Radziwills, Franklin Roosevelt Jr., his wife, and others for island sightseeing, on-board bouzouki dancing, and dining on caviar, foie gras, and lobster. Within a few days observers noticed Jackie and Onassis spending a good deal of time alone on the yacht's deck, deep in conversation. At the end of the cruise, Onassis, the richest man in the world, gave Jackie a diamond-and-ruby necklace valued at more than fifty thousand dollars.

"I'm so glad to be home!" Jackie cried when she saw her husband and children running to greet her plane as it touched down in Washington on October 17. As much as she had enjoyed the cruise, she found she missed her family tremendously. She spoke to them every day from the yacht except when the phone lines were down, and then she wrote letters. "I miss you very much," she told Jack in one. "I know I always exaggerate everything, but I realize here that I am having something you can never have—the absence of tension. I wish so much that I could give you that. . . ."

On the south balcony of the White House on November 13, the first family enjoy the bagpipes of Britain's Black Watch Regiment.

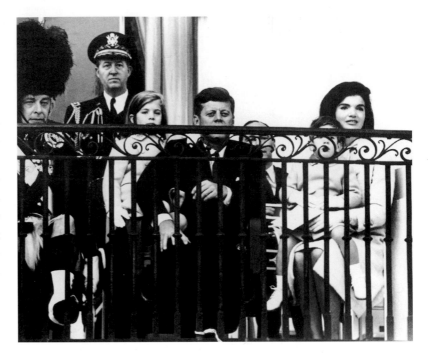

The death of their newborn baby had brought Jack and Jackie closer than they had ever been. "They'd certainly been through as much as people can go through together in ten years," Jackie's mother said. "I almost can't think of any married couple I've ever known that had greater understanding of each other."

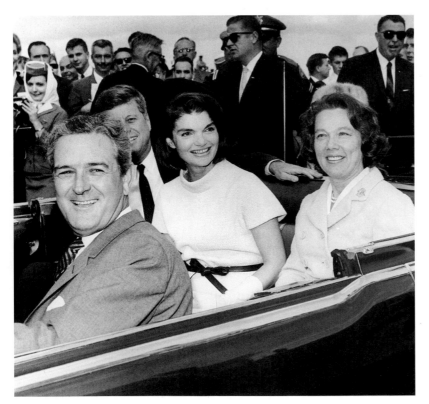

An indication of their new closeness was Jackie's willingness to accompany Jack on a trip to Texas, her first domestic foray with him since he assumed office. The trip was important to Jack's chances of winning Texas in the next election, and Jackie knew that her presence would help make the visit a success. Governor John Connally and his wife, Nellie, met the Kennedys at San Antonio Airport on the afternoon of November 21. Jackie proved as popular in the Lone Star State as everywhere else, and editorial writers suggested that she alone might be responsible for winning Texas's electoral votes for the Kennedy-Johnson ticket in 1964.

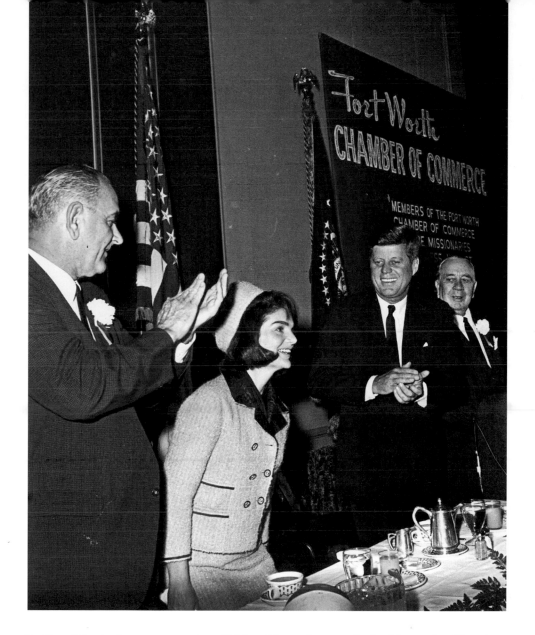

In Fort Worth the next morning, Friday, November 22, Jack addressed a Chamber of Commerce breakfast in their hotel's main ballroom. Jackie entered the room a half hour late, looking lovely in an often-worn outfit the president had picked out for her to wear that day—a raspberry-colored wool suit, matching pillbox hat, and white gloves. The two thousand attendees—many standing on their chairs—cheered, applauded, and whistled appreciation when she arrived.

"Two years ago," President Kennedy told them, "I introduced myself by saying I was the man who had accompanied Jacqueline Kennedy to Paris. I am getting somewhat the same sensation as I travel around Texas. Nobody wonders what Lyndon and I are wearing."

Then the Kennedys departed by plane for Dallas, the final stop on the trip. The highlight was to be a long motorcade through the city streets in an open car.

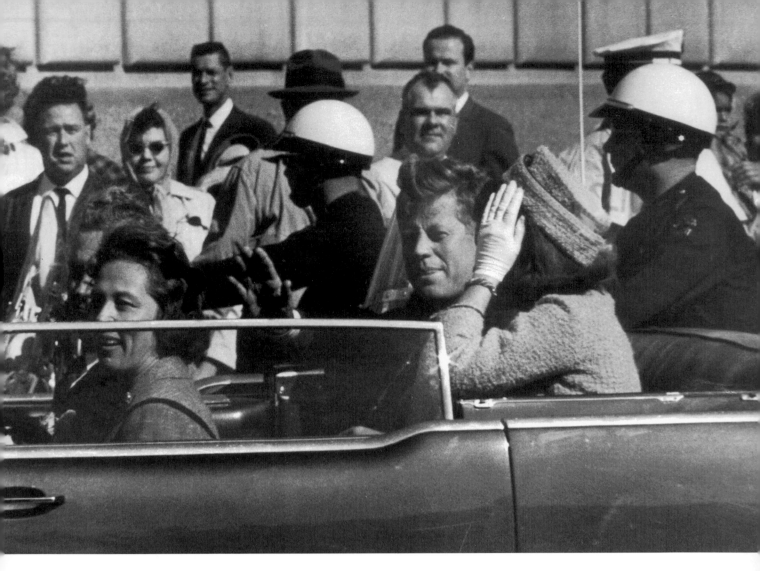

It was hotter than she had expected, and the sun glared in her eyes, but Jackie didn't wear sunglasses because tens of thousands of people had lined the streets to see her and Jack. They cheered and applauded as their car drove slowly by; they held placards asking the president and first lady to stop and shake their hands. The Secret Service had pleaded with Jack to let them put a bullet-proof enclosure on top of the car, but he wanted potential voters to see him and Jackie as clearly as possible.

As the motorcade wended its way through Dealey Plaza, Jackie noticed an overpass up ahead and thought it might offer some relief from the hot sun. Nellie Connally recalled that "the crowds were so enthusiastic and so loving, we didn't get to do much chatting because of the noise. But I was so pleased with our reception, I turned around in my seat and said, 'Mr. President, you can't say Dallas doesn't love you.'"

Moments later Jackie heard what she assumed was another police escort motorcycle backfiring. Then Governor Connally cried, *"No, no, no!"* Jackie looked over at Jack. His hands clutched at his throat.

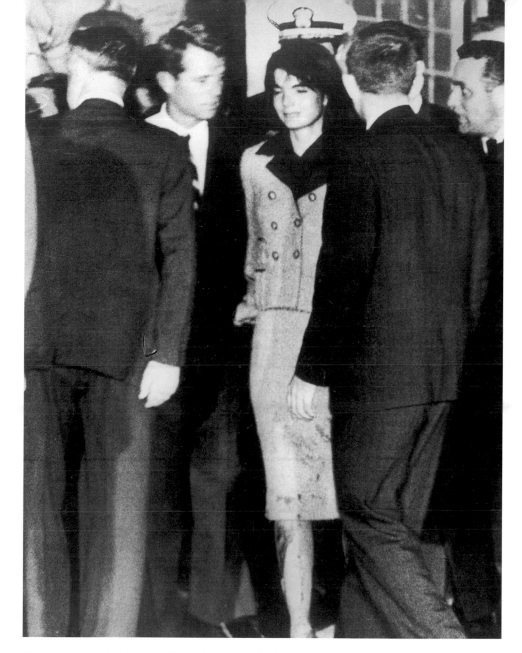

The president's blood still on her suit, Jackie accompanies his flag-draped coffin back to Washington's Andrews Air Force Base, where Attorney General Robert Kennedy has met her. JFK's last words had been "I am hit!" before the top of his head was torn apart by a second bullet from a high-powered rifle. Governor Connally was also shot. A presidential commission would later decide that Lee Harvey Oswald, a Communist sympathizer acting alone, was the assassin.

As Jackie cradled her husband's shattered head in her lap, trying to keep his brains from spilling out, she had murmured, "I love you, Jack." On the plane ride back from Dallas, aides had urged the first lady to wash the president's blood from her stockings and clothes. She refused. "I want the world to see what they did to my husband," she said.

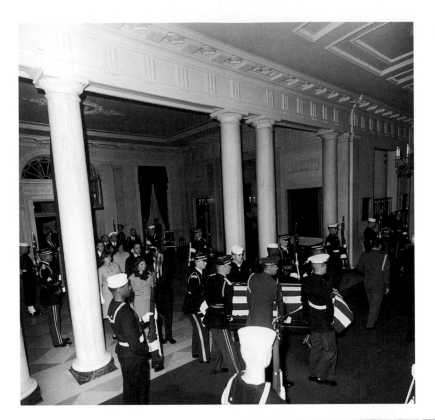

Jackie and Bobby follow the president's casket into the White House in the early-morning hours of November 23. Visible behind them are Jean Smith, Sargent Shriver, presidential aide Ted Sorensen, and Ethel Kennedy.

The president's widow and her children leave the White House, followed by Bobby Kennedy and Pat Lawford, as the president's casket is moved to the Capitol rotunda, where it will lie in state. Jackie planned every aspect of the funeral, which she wanted to be as much like Abraham Lincoln's as possible. She handwrote lists of people to be invited, and chose the music, the church, the prayer, and the photograph that would be used on the funeral card. "Her sense of history came through on this occasion," her press secretary later said. "She knew it had to be the most fitting funeral possible."

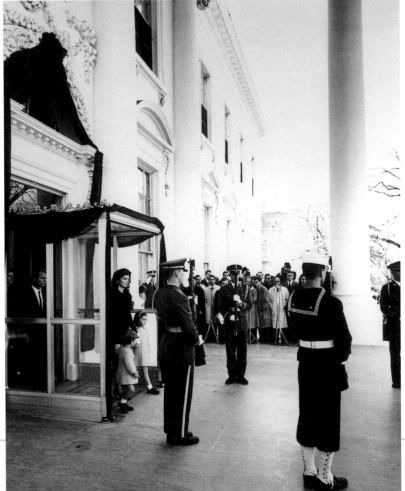

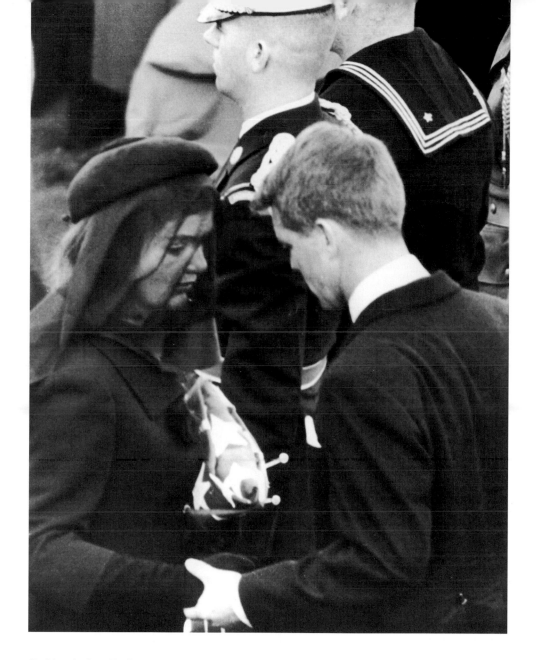

Bobby helps Jackie with her footing after the president's burial at Arlington National Cemetery on November 25. She carries the flag that had draped his coffin. She chose Arlington over a family plot in Brookline, Massachusetts, Jack's birthplace, because she felt it more befit his position, and she selected a site on the side of a small hill within sight of the Lincoln Memorial.

Jackie's almost preternatural calm and dignity in the face of such a catastrophe helped America through the ordeal of the president's death and its aftermath—including the gunning down of his alleged assassin. Clearly devastated, her face puffy from crying, she nonetheless proved to be "a pillar of strength," as Ted Kennedy put it. "It helped all the rest of us carry on."

After the funeral, the president's widow and his brother Ted—who had been elected to replace Jack in the Senate—stood in a receiving line and thanked every one of the hundreds of world dignitaries who had attended the funeral. White House photographer Cecil Stoughton recalled wondering how on earth they were able to do it. Standing fourth in this line is Golda Meir, who would later become Israel's prime minister.

On December 3, Jackie takes part in a ceremony honoring Secret Service agent Clint Hill for "exceptional bravery." Hill had jumped on the back of the president's limousine and pushed Mrs. Kennedy, who had scrambled onto the rear hood of the car in terror and disorientation, back into her seat. He then used his body to shield her and the president from any further gunshots.

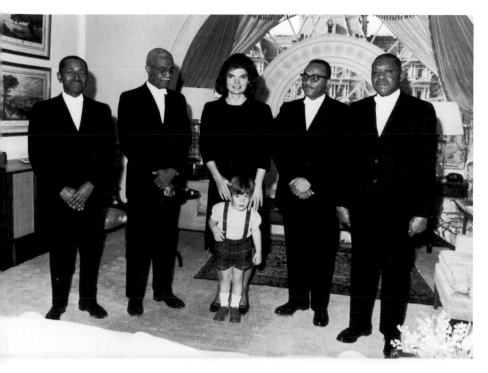

On December 6, Jackie smiles gamely as she and John say good-bye to the staff before moving out of the White House. It proved a difficult experience for her. "At first I didn't want to come to this house," she said. "Now I can't seem to leave."

Later that day Jackie enters her new home in Georgetown, which Averell Harriman had lent to her until she could buy a place of her own. Within a few weeks, she did—a town-house across the street.

To keep her grief at bay, she personally answered some of the thousands of pieces of mail she received in December. She wrote to Nikita Khruschev, thanking him for sending an envoy to the funeral. He and JFK, she told the Soviet leader, "were adversaries, but you were allied in a determination that the world should not be blown up. . . . The danger that troubled my husband was that war might not be started so much by the big men as by the little ones. While big men know the

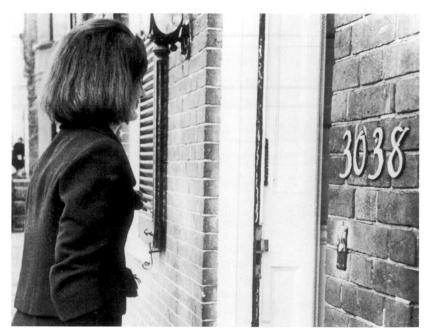

need for self-control and restraint, little men are sometimes moved more by fear and pride."

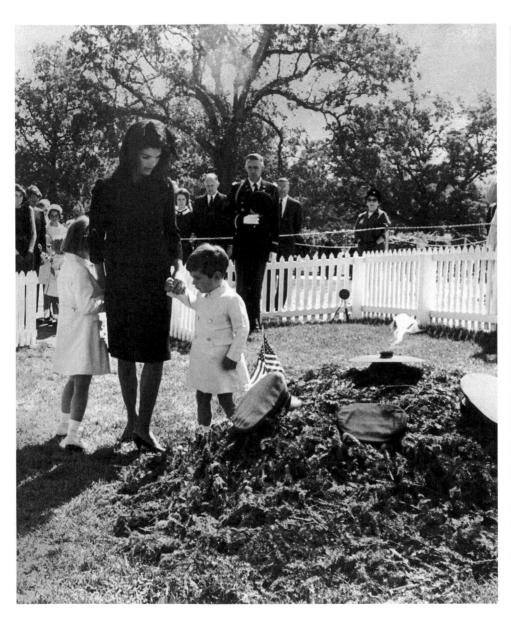

November 1964: Jackie and the children visit JFK's grave with its eternal flame on the first anniversary of his death.

The President's Widow

The rush of the holidays had cushioned her, as did the stream of world dignitaries come to express their condolences. But as her workload diminished, as the callers grew less frequent, a crushing despair set in. She felt, she said, as though a great chunk of herself had been cut out, and what remained amounted to little.

"Jack was the love of my life," she told a friend. "No one will ever know how big a part of me died with him." To another intimate she said, "I'm a living wound. My life is over. I'm dried up—I have nothing to give, and some days I can't even get out of bed. I cry all day and all night until I'm so exhausted I can't function. Then I drink."

A living wound perhaps, but not for long a casualty. Jacqueline Kennedy possessed too much strength of character to let the calamity she had suffered destroy her as a similar one had Mary Todd Lincoln, who was institutionalized in an insane asylum ten years after her husband's assassination. For the children, at least, she would shake off her despair and try to give them as normal an upbringing as possible, one away from politics. She turned down an offer to become ambassador to France, and within a year she moved to New York City.

She explained herself to Pierre Salinger, her husband's press secretary. "There's only one thing I can do in life now—save my children. They've got to grow up without thinking back [to] their father's murder. They've got to grow up intelligently, attuned to life in a very important way. And that's the way I want to live my life, too."

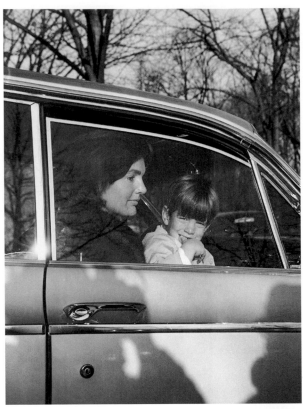

After spending the Christmas holidays with the Kennedys in Palm Beach, Jackie and the children returned to Georgetown on January 5, 1964. The next day, John and his mother drive off after accompanying Caroline to the British Embassy, where she was enrolled in first-grade classes. A bright little girl, Caroline was able to read far ahead of her age group.

Boston's Richard Cardinal Cushing escorts Jackie to her seat at Holy Cross Cathedral for a solemn pontifical Mass in honor of JFK on January 19.

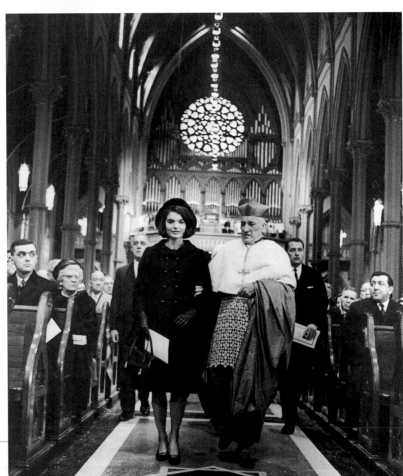

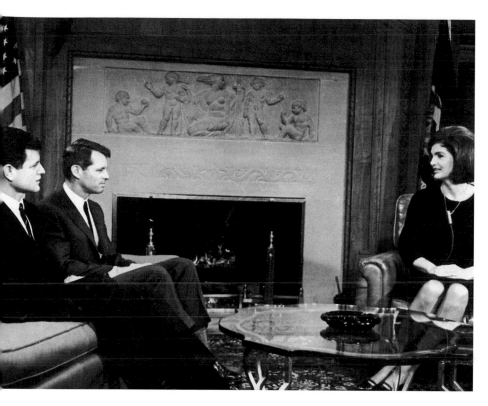

Also in January, Jackie made a nationally televised appearance with Bobby and Ted to thank Americans for the hundreds of thousands of letters they had sent to express their sorrow at the president's loss. "The knowledge of the affection in which my husband was held by all of you has sustained me, and the warmth of these tributes is something that I will never forget," she said.

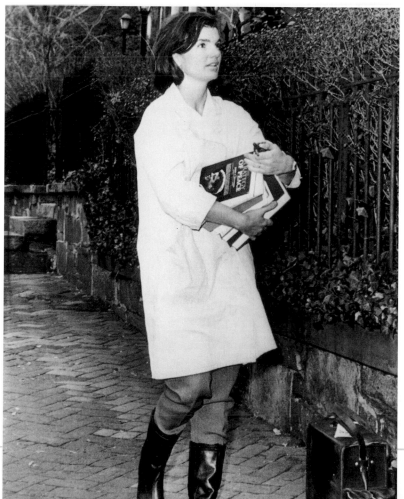

Jackie carries an armful of books—including JFK's *The Strategy of Peace*—into her new fourteen-room Georgetown home on February 1. Once her new address became public, Franklin Roosevelt Jr. recalled, "Jackie became Washington's number-one tourist attraction. Morning, noon, and night the street was clogged with people peering in at her and the children." Jackie kept the drapes tightly drawn, but whenever she went out, police had to clear a path for her. "The tour buses with hundreds of tourists hanging out the windows would rumble down her street," Roosevelt added. "It [became] a nightmare."

In the spring of 1964, Jackie plunged herself into the planning of the John F. Kennedy Library. She became involved in all aspects of the project, including the fund-raising, site selection, and design. Here, she goes over materials with Bobby and one of the library's trustees. Jackie wanted the library to be not only a repository for JFK's official papers, but to reflect him as a man. "I wanted people to see the rather personal side of the president, so I have parted with some of our greatest treasures— the pictures, objects, and books which we always kept at home."

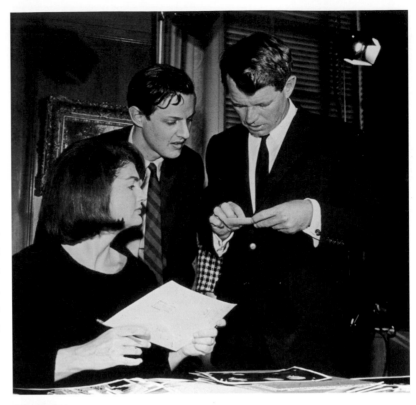

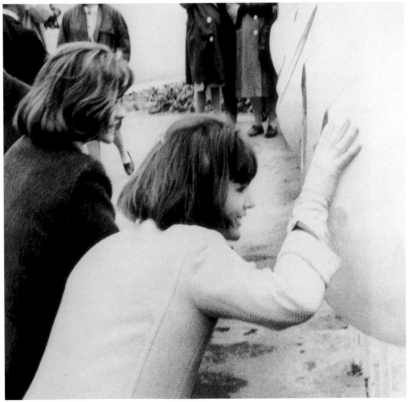

In April, Jackie visited the World's Fair in Queens, New York. Here she looks into a "pearl" at the Clairol Color Carousel to see how she would look as a blonde while Jean Kennedy Smith waits her turn.

94

May 29, 1964, would have been John F. Kennedy's forty-seventh birthday. Jackie took the occasion to speak again on television, this time to audiences in Europe, during which she thanked them for their messages and urged donations to the Kennedy Library Fund. Here, a British family listens intently to her talk. She taped similar messages in French, Spanish, and Italian.

Appearing before the cameras, she admitted, made her nervous. "I wish I knew when to breathe," she said. "I just don't know how actresses can do it."

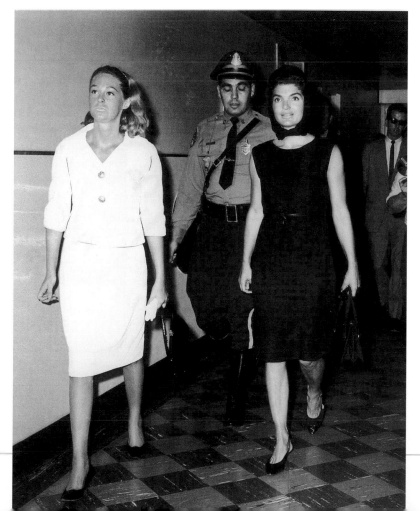

More heartache for the Kennedys. On June 18, Ted Kennedy's small plane crashed on its way to a Massachusetts state Democratic convention poised to nominate him for election to a full term in the U.S. Senate. The pilot was killed; Ted suffered a broken back. On June 21, Jackie joined Ted's wife, Joan, on a visit to his bedside at Cooley Dickinson Hospital in Northampton, Massachusetts. Ted spent months strapped into bed to keep his back immobile, won election by a landslide, and—using a cane—took his seat in the Senate again in January 1965.

July 28, 1964: A security guard is reflected in the glass of Jackie's car at La Guardia Airport as she waits to be driven into Manhattan on her thirty-fifth birthday. She celebrated the evening quietly with friends, then spent the rest of her visit meeting with the JFK Library trustees and attending to personal business.

From New York, Jackie flew to London to pick up her sister Lee, then both took a vacation cruise along Yugoslavia's picturesque Dalmatian coast. Here, on August 8, they visit the Cyclopic Walls ruins on the island of Hvar.

Jackie beams through the window of her private plane at New York's newly renamed John F. Kennedy Airport on August 20 as she heads up to Cape Cod for a vacation.

Jackie and her sisters-in-law (left to right) Eunice Shriver, Pat Lawford, and Jean Smith had arrived in Atlantic City, New Jersey, to attend the Democratic National Convention on August 18. The convention turned into an emotional outpouring for the slain president; when RFK introduced a twenty-minute tribute film about his brother, the ovation he received lasted almost as long.

At a reception arranged by Averell Harriman, Jackie stood next to Bobby and Lady Bird Johnson for three hours and shook thousands of hands. The crush was so great to see her that a plate-glass window shattered. To some, Jackie seemed like a mechanical doll. "But," wrote Shana Alexander, "for all its air of unreality, Mrs. Kennedy's performance and the response it evoked was the most touchingly real event of the convention."

After a few days on the Cape, Jackie and the children spent some time at Hammersmith Farm, her mother and stepfather's estate. On August 25, Jackie and Caroline had an impromptu picnic on a rocky ledge along Narragansett Bay, which fronted the Auchincloss property.

Although John was too young to fully understand the loss of his father, seven-year-old Caroline suffered. Months after his death, she and a friend pulled apart a wishbone, and her friend asked Caroline what she had wished for. "To see my daddy again," she said.

September 15, 1964: A busy day for Jackie. To escape the fishbowl in which she found herself in Georgetown, she bought a co-op at 1040 Fifth Avenue in Manhattan. There, she hoped, the sheer size of New York City would afford her some degree of anonymity. She moved into the fifteen-room apartment overlooking the Metropolitan Museum early in September. On this morning, she took Caroline to her first day of classes at the Convent of the Sacred Heart on East Ninety-first Street. Later in the day (top right) she welcomed her first visitors to her new office at 200 Park Avenue. Here she and John pose with Seiicho Tokuyama of Japan, who donated a $1,000 pearl necklace to the Kennedy Library on behalf of twenty-eight Japanese mayors. Finally, a visit to Uncle Bobby's Senate campaign headquarters on East Forty-second Street.

After he was passed over as Lyndon Johnson's running mate, the attorney general decided to seek elective office for the first time and ran for the Senate against New York Republican Kenneth Keating. Although opponents called him a carpetbagger, he easily won the race and joined Ted in the Senate in January.

On Christmas holiday in Aspen, Jackie carries her tired son as Caroline leads the way back to their lodge. The three had spent an afternoon romping in the snow.

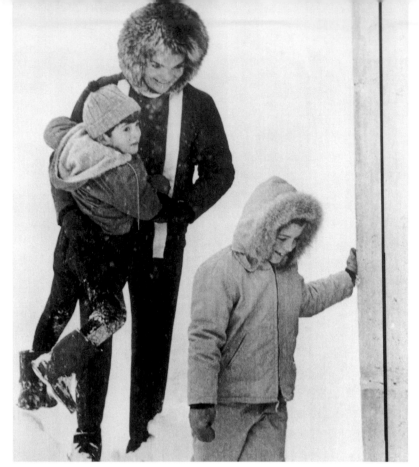

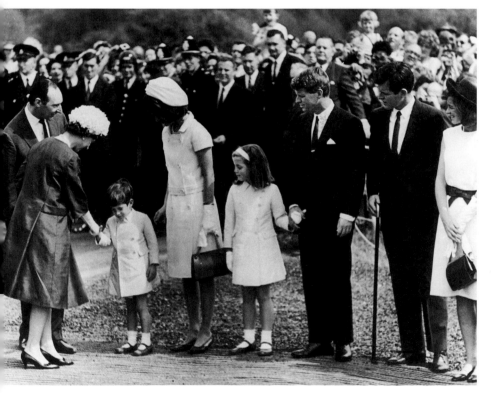

In May 1965, the Kennedys traveled to England for the dedication of the British memorial to JFK at Runnymede. On May 14, Lord Harlech, Britain's former ambassador to the United States, introduced John F. Kennedy Jr. to Queen Elizabeth II as the rest of the family waited their turn. At far right is Jean Kennedy Smith.

September 24, 1965: Holding a copy of Gerald Gardner's book *Robert Kennedy in New York,* Jackie kisses John good-bye in Boston as she leaves to get ready for a charity ball that evening.

Jackie and Ted share an intimate moment at the ball, a $1,000-a-box benefit for the Boston Symphony Orchestra on the occasion of its eighty-fifth anniversary. This was Jackie's first social appearance in Boston since JFK's death.

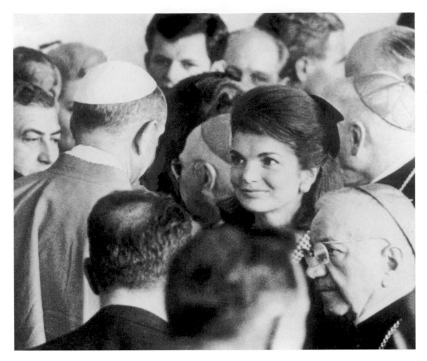

On October 4, Jackie meets Pope Paul VI in a receiving line before his address to the United Nations General Assembly in New York. Ted can be seen waiting his turn behind her.

Franklin D. Roosevelt Jr. escorts Jackie to the premiere of *The Eleanor Roosevelt Story,* a documentary film about his mother, on November 7. Two weeks later, Jackie commemorated the second anniversary of her husband's death privately.

Jackie arrives by helicopter in Gstaad, Switzerland, on January 16, 1966, for a skiing vacation with her children. Caroline is in the backseat, obscured by her brother.

Skiing, on water or snow, was one of the few sports Jackie enjoyed, and she proved proficient at it. Here she and her instructor ascend a mountainside freestyle—without the help of poles.

Three months later, Jackie traveled to Europe again, this time alone, for Spain's week-long festival *Feria di Seville*. She watched several bullfights, turning away whenever a matador lanced a bull. She attended the International Red Cross Ball, a glitzy charity event at the Duke of Medinaceli's Casa de Pilatos, where she upstaged Princess Grace (much to Grace's reported annoyance). She applauded flamenco dancers and, dressed in a red velvet bolero jacket, black riding chaps, and black broadbrimmed hat, sipped sherry as she rode a white stallion around the festival grounds. In this photo she is shown riding a carriage through the streets of Seville along with her hosts, the Duke and Duchess of Alba and the Angier Biddle Dukes.

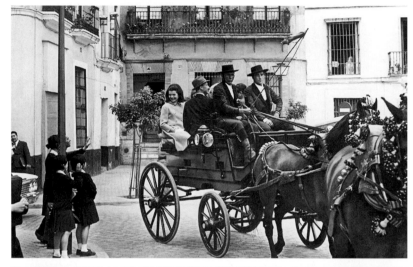

Her Spanish trip a huge success, Jackie flew to London to visit the Radziwills on April 26.

Jackie managed to keep most details of her private life from public view. Whenever she was seen with a man, rumors of romance usually arose, but she never acknowledged any relationship. Jackie was linked with Lord Harlech, the former Undersecretary of Defense Roswell Gilpatric, Spain's ambassador to the Vatican Antonio Garrigues, and the financier Andre Meyer. She also apparently had brief flings with Marlon Brando and Warren Beatty. As Jackie's relative-through-marriage Gore Vidal put it, "Jackie had her share of affairs with the famous."

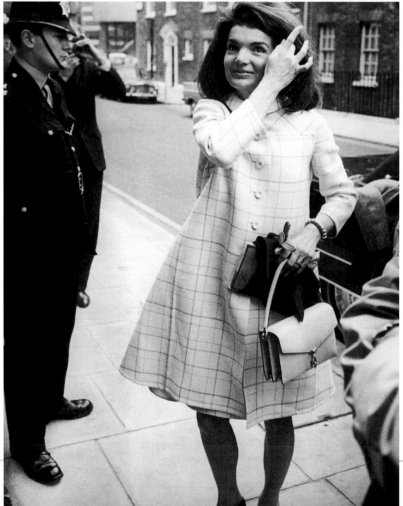

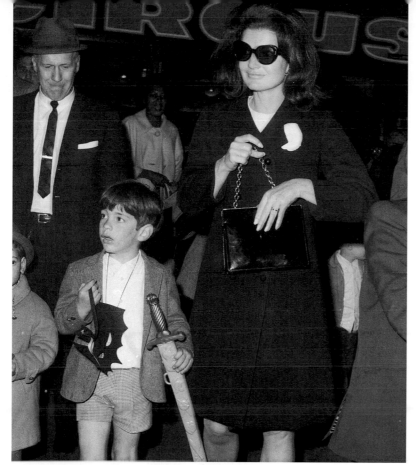

Back in New York, Jackie took John and Caroline to the circus at Madison Square Garden on May 11. John, five and a half, picked up a souvenir sword and mask. "He's something else," Jackie said of her son. "He makes friends with everyone. Immediately. He surprises me in so many ways. He seems so much more than one would expect of a child [his age]. Sometimes it almost seems that he is trying to protect me instead of the other way around."

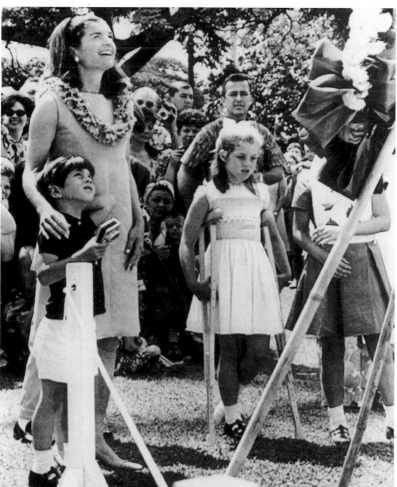

A month later, another trip—this one to Hawaii with Peter Lawford. Pat had divorced Peter shortly after the assassination, but he and Jackie remained friends. Peter, for whom Hawaii had been a second home since childhood, acted as a tour guide, and threw a lavish party for Jackie and 150 guests at the Kahala Hilton. In this photo, Jackie and the children join other tourists to gaze at the statue of King Kamehameha during the annual parade in his honor in Honolulu. Caroline hobbles around on crutches after cutting her foot on some coral reef while swimming.

The epitome of glamour, Jackie sweeps into a Kennedy Library fund-raiser in Boston on the arm of Harvard University president Nathan Pusey on October 17, 1966. With them is Averell Harriman. Originally, the Kennedy Library was to be built on the grounds of Harvard, JFK's alma mater. This was later changed to a site overlooking Boston's Dorchester Bay.

With a swing to rival Red Sox slugger Carl Yastrzemski's, Caroline christens the *U.S.S. John F. Kennedy* at the Newport News shipbuilding yards on May 27, 1967. President Johnson, John, Jackie, and Newport News Shipbuilding president D. A. Holden look on.

Late the following month, Jackie has her son well in tow as they board a flight for Dublin for a six-week Irish vacation. A huge crowd greeted them at Shannon Airport. "I am so happy to be here in this land my husband loved so much," Jackie said. "For myself and the children it is a little bit like coming home, and we are looking forward to it dearly."

On a friend's estate in Waterford, Jackie sits astride Emily and checks out John's form on Pal. John seems a little unsure, while Caroline's clearly impatient to get her pony, Danny Boy, galloping.

Jackie's trip to JFK's homeland caused a stir unrivaled there since his own visit in 1961. On July 8 she stopped by the famous glass-works in Waterford. Delighted employees applauded her and presented her with a crystal bowl.

After her friend Roswell Gilpatric lent her some books about the Yucatan Peninsula, Jackie persuaded him to join her on an archaeological sightseeing trip to Mexico in March 1968. They visited Mayan ruins like this one at Campeche, and Jackie kept detailed notebooks with an eye toward writing a book and donating its proceeds to an educational project in the region.

"She was very intense" about learning the history of the Mayan culture, Gilpatric recalled. "She wanted to experience the ruins by moonlight on horseback, to get the feeling of the past, and even walked into the water to get close to them. It was essential to her nature. When she got interested in a subject, she thoroughly immersed herself."

Jackie arrives in Atlanta, Georgia, on April 9 to pay her respects to the widow of civil rights leader Dr. Martin Luther King Jr., slain by an assassin on April 4. "Your husband," she told Coretta Scott King, "was one of the greatest and most inspiring leaders that any of us has known. I share your grief in this hour of sorrow, but his death will help to free us from the violence and tragedy which hate often produces."

Privately she wasn't as hopeful. Bobby Kennedy had a few weeks earlier announced his intention to challenge Lyndon Johnson, who had been beleaguered for several years by the country's growing anti–Vietnam War sentiment, for the Democratic presidential nomination. "Do you know what I think will happen to Bobby?" she said to Arthur Schlesinger. "The same thing that happened to Jack . . . There is so much hatred in the country, and more people hate Bobby than hated Jack. . . . I've told Bobby this, but he isn't fatalistic like me."

Despite her fears, Jackie campaigned with Bobby in New York, attending a fund-raiser with him in May. After President Johnson withdrew from the race, Bobby, Vice President Humphrey, and Minnesota Senator Eugene McCarthy became the main contenders for the Democratic nomination in Chicago that summer. The party establishment rallied around Humphrey, who did not actively run in the primaries, while most of the younger rank-and-file responded to McCarthy's antiwar fervor and Kennedy's populist themes.

Bobby went on to win four of the five primaries he entered, and hoped to knock McCarthy out of the running with a victory in California on June 4.

Bobby won the California primary and told a cheering crowd at the Ambassador Hotel in Los Angeles, "Now it's on to Chicago, and let's win there!" As he left the building through the kitchen, he was shot in the head by a Jordanian immigrant, Sirhan Sirhan, who opposed his pro-Israel views. Bobby died a day later. On June 7, at St. Patrick's Cathedral in New York, thousands of Americans stood in line to file past Bobby's bier. Here Jackie, Caroline, and John touch Bobby's flag-draped coffin, just as they had touched President Kennedy's in 1963.

Bobby's assassination devastated Jackie. She feared for her family, and she blamed America, which seemed caught in a maelstrom of violence. "If they're killing Kennedys," she told a friend, "my kids are number-one targets. . . . I want to get out of this country!" Four months later, she would have a new homeland—and a husband so wealthy he could protect her and her children on his own private island.

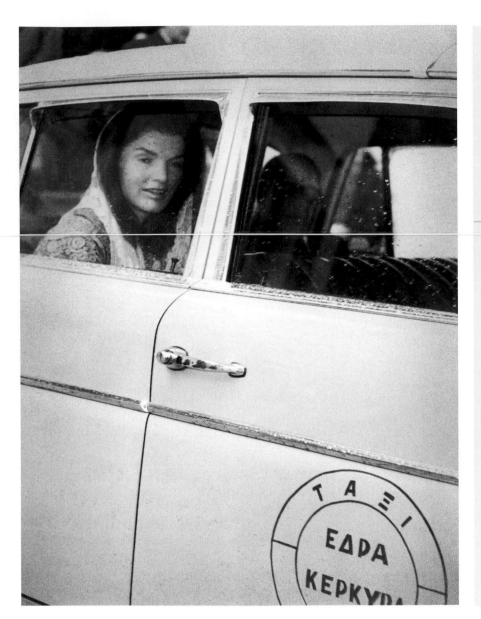

Mrs. Aristotle Onassis is taxied to church services on the island of Skorpios in 1970.

part five

The Greek Tycoon's Wife

At first look Aristotle Socrates Onassis seemed the antithesis of John F. Kennedy. Short and overweight, nearly seventy-two years old, he had the kind of gruff appearance that prompted the unkind to describe him as "toadlike." Few considered him a suitable consort for the lovely young widow.

Still, the two men shared similarities. Wealth. Power. Intelligence. A strong sense of self. Most of all, a personal magnetism that drew people to them, won their admiration and affection. They shared, too, an attraction to the woman born Jacqueline Bouvier, and for many of the same reasons. "There's something provocative about that lady," Onassis said when he first met her in 1955. "She's got a carnal soul."

The announcement of the impending marriage, not long after Bobby's death, set off a firestorm of condemnation in the United States. Commentators wailed that Jackie would besmirch the cherished memory of her late husband by marrying this *foreigner,* this ugly man old enough to be her father.

Lee Radziwill neatly summed up the reasons for the reaction—and the marriage. "If my sister's new husband had been blond, young, rich, and Anglo-Saxon, most Americans would have been much happier. . . . [But] she loves Onassis. Onassis is rich enough to offer her a good life and powerful enough to protect her privacy." Her stepbrother Yusha Auchincloss revealed that Jackie had been attracted to more than just the money and the security Onassis could provide her: "Onassis made Jackie truly happy—something we really hadn't seen in a long time. She was enjoying life again."

For Jackie, few opinions mattered—except for Rose Kennedy's. The matriarch admitted to misgivings. "I thought of the difference in their ages. I thought of the difference in religion . . . and the fact that he had been divorced."

Nevertheless, Rose's blessing came. "It seemed to me that Jackie deserved a full life, a happy life. . . . When she called I told her to make her plans as she chose to, and to go ahead with them with my loving good wishes."

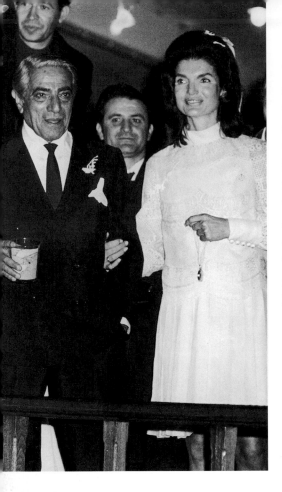

The newlyweds pose for pictures after the wedding. The Greek Orthodox ceremony was performed in the century-old Chapel of the Little Virgin on Skorpios, Onassis's 350-acre island in the Ionian Sea on Greece's west coast. Amid candles and gardenia bushes, the couple kissed a copy of the New Testament, symbolically drank red wine from a chalice, and held hands for the dance of Isaiah.

Jackie importuned the press not to infringe on the privacy of the ceremony. "We wish our wedding to be a private moment in the little chapel among the cypresses of Skorpios with only members of the family present. . . . If you will give us these moments, we will gladly give you all the cooperation possible for you to take the pictures you need." The paparazzi complied.

Afterward, in a cold, driving rain, Onassis got behind the wheel of a decidedly unglamorous jeep to drive his bride and Caroline through a crush of gawkers and well-wishers. The reception aboard Onassis's yacht *Christina* lasted into the early-morning hours and featured bouzouki dancing, an enormous wedding feast, and rivers of champagne and Greek wines. The groom presented his bride with $1.2 million worth of jewels, and gave valuable trinkets to the guests.

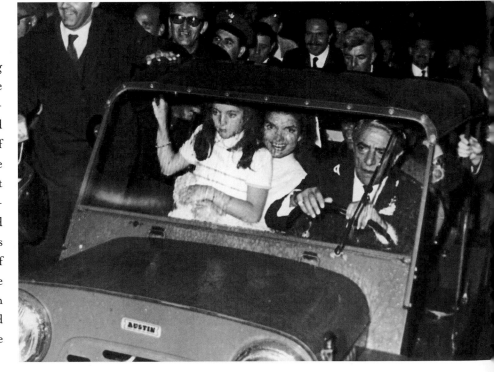

Ten days after her wedding, Jackie takes a dip in the Ionian Sea. Her honeymoon, delayed by a few days while Ari attended to the details of a half-billion-dollar governmental project, consisted of idyllic days on Skorpios with Onassis spent fishing, swimming, sunbathing, and strolling. The couple also made two brief trips to Athens (one for pleasure) and sailed the *Christina* to the island of Rhodes.

Although Jackie's marriage did offer her the security of her own private island and police force, it did nothing to lessen the world's interest in her. She became the number-one target of Europe's paparazzi, who grew relentless in their efforts to photograph her. In February 1969 she took a brief trip to Lausanne, Switzerland, during which swarming reporters and photographers made her a virtual prisoner in her hotel room. To placate them, she agreed to a press conference on her last day there, but then she failed to show up for it. When a photographer spotted her leaving the hotel by a side entrance, he gave a young girl three red roses to present to her as a peace offering. Jackie kept a few steps ahead of the child until she reached her car, when she reluctantly accepted the flowers.

The resourceful paparazzi often resorted to high-powered telephoto lenses to shoot Jackie when she most expected privacy. This photo, surreptitiously captured in March 1969, should allay concerns that Jackie's marriage to Onassis was little more than a loveless convenience. Onassis, in fact, bragged to friends that they made love "five times a night—she surpasses all the women I have ever known." According to Pierre Salinger, Onassis "was very graphic in the way he would describe their sexual relationship. Believe me, it was more than any of us wanted to hear."

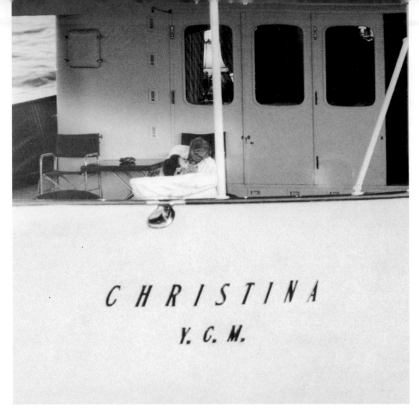

In April, Jackie took a cruise aboard the yacht to the Bahamas with her children and several of their friends, Ari, Christina, and Rose Kennedy. Rose visited Jackie in Greece three times in the year after the marriage, proof that her blessing for the union was genuine and not just for the benefit of public relations. The family members came ashore in Nassau in groups, then scattered to do their own sightseeing. As for Rose and Jackie, the photographer's caption for this photo reads, "The two spent hours shopping in town, but did not buy anything."

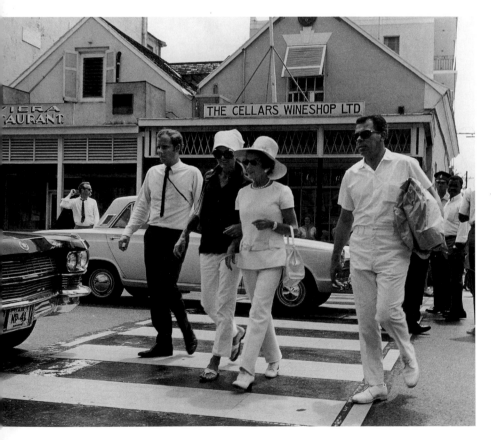

"March, young man!" Back on Skorpios, Jackie assumes her sternest motherly stance to make sure nine-year-old John dresses for dinner. By all accounts Jackie was a strict but loving mother who refused to let her children grow up spoiled by the privilege their wealth and name afforded them.

Later in life John would describe Aristotle Onassis as "the only father I ever knew," a man who treated him well and of whom he was quite fond. Ari took John fishing (he once gave him several hundred-dollar bills with which to buy some worms) and to ball games. Here the entire family watch the "Miracle" New York Mets play the fifth game of the 1969 World Series against Baltimore at Shea Stadium on October 14. The home team won, 5–0, and the Mets went on to win the series in an upset.

Jackie made efforts to ensure that John didn't forget his father. "I want to help him go back and find his father," she said. "It can be done. There was that stone his father placed on a mound during a visit to Argentina a long time ago, and then when I took the

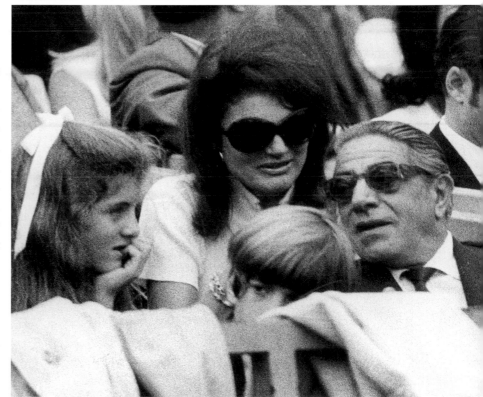

children there later, John put a stone on top of his father's. He'd like to go back and see his stone, and his father's stone—and that will be part of knowing his father."

On November 17, 1969, Joe Kennedy died at the age of eighty-one. Jackie had rushed to Hyannis Port when she heard the news that he was failing, and after his death recited the Lord's Prayer at his bedside along with the family. In this photo, Jackie and John arrived at the funeral services.

A happier occasion three weeks later, December 11: Jackie beams as she and her children watch the lighting of the Christmas tree in Manhattan's Rockefeller Center.

December 23: At Lee Radziwill's home in England for the holidays, Jackie, Caroline, and John join Lee and her son, Anthony, as they forage for boughs with which to decorate the house.

Yes, even Jackie Onassis can have a bad hair day: Jackie on a windswept Skorpios street in the spring of 1970.

That summer, Jackie, Lee, Ari, the children, and a group of friends cruised aboard *Christina* to the Italian island of Capri. The party strolled the main shopping area and dined in an open-air café, always surrounded by hundreds of rubbernecked sightseers and photographers. After dinner, Jackie bought an ice-cream cone from a vendor, much to the amusement of the crowd.

By the next day, Jackie had had her full of the attention. Here she shows her displeasure at being photographed barefoot.

Holding a copy of the London *Times* Sunday magazine, Jackie arrives at Heathrow Airport on September 7. She, Ari, and his twenty-two-year-old son, Alexander, were headed for Northern Ireland to inspect two supertankers under construction for Onassis at the Harland-Wolff shipyard.

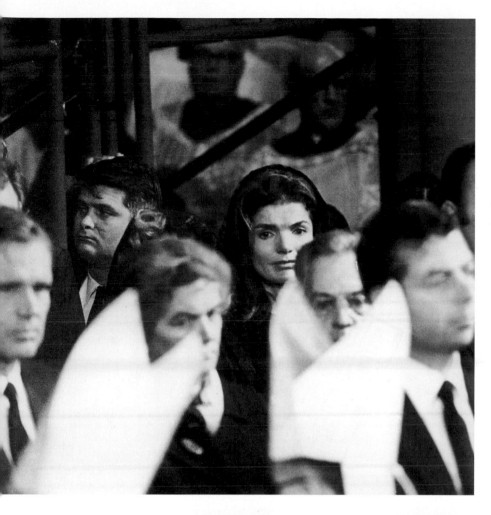

Early in November, Jackie returned to the United States to attend the funeral of Richard Cardinal Cushing in Boston. The Cardinal had officiated at her marriage, christened Caroline, led prayers at President Kennedy's inauguration, observed the funeral Masses for baby Patrick and JFK, and given his blessings to Jackie's marriage to Onassis. His funeral undoubtedly brought back a flood of memories for her.

"Bewigged and beautiful," the press called Jackie as she attended a performance of one of her favorite shows, *Hair,* at Broadway's Biltmore Theater in December 1970.

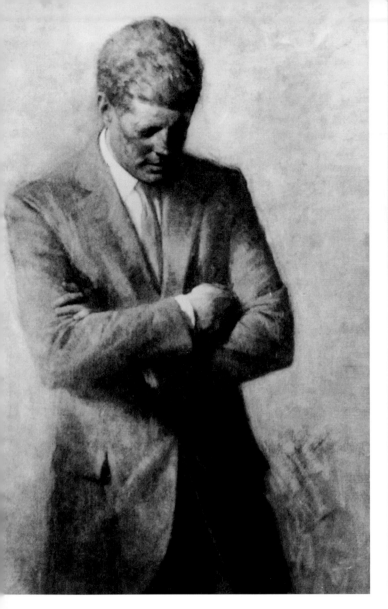
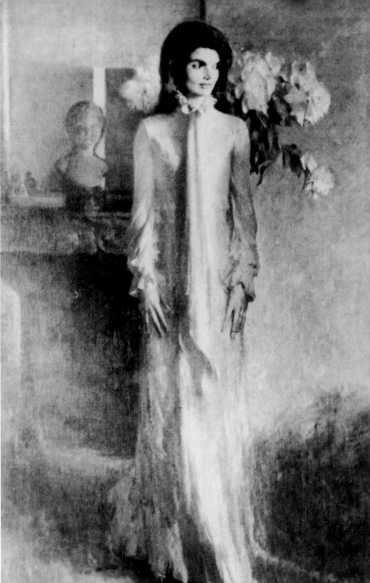

The official White House portraits of President and Mrs. Kennedy by New York artist Aaron Shikler. He had tried to capture, Shikler said, Jackie's "extraordinary—almost spooky—beauty." First Lady Pat Nixon invited her and the children to the White House for an unveiling ceremony for these portraits, but she declined. "The thought of returning to the White House is difficult for me," she wrote in reply. "I really do not have the courage to go through an official ceremony, and bring the children back to the only home they both knew with their father under such traumatic conditions. With the press and everything, something I try to avoid in their little lives."

The Nixons agreed to a private viewing, and Jackie, Caroline, and John returned to the White House—for the first and last time—on February 3, 1971. After the viewing, they dined privately with President and Mrs. Nixon and their daughters, Tricia and Julie.

March 1971: Thirteen-year-old Caroline holds a pane of glass as she and her mother trudge through the snow along Fifth Avenue at the border of Central Park. Later in the year Caroline enrolled in a prestigious prep school, Concord Academy, where she distinguished herself with good grades and physical courage: She became a daring horsewoman and took flying lessons. She also proved headstrong and sometimes rebelled against her mother's strictures. "Do you have the same problems with your girls as I have with Caroline?" Jackie asked a friend around this time. "She knows everything and I don't know anything. I can't do anything with her."

With the advent of warmer weather by early May, Jackie, Caroline, ten-year-old John, and Jackie's niece Peggy McDonnell arrive at the Somerset Hills Pony Club to compete in a horse show.

On a Mediterranean cruise in June, Jackie caused a sensation when she appeared braless during a shopping foray into Portofino, Italy. A year later, even more of Jackie was revealed when ten paparazzi with wetsuits and telephoto lenses managed to snap her and Onassis sunbathing naked in Skorpios. The photographs were published in men's magazines worldwide. Privately, Jackie was mortified. Publicly, she laughed it off. "I suppose I should be flattered," she said.

"Never chew in public" was one of Jackie's dictums for retaining one's dignity while in the glare of the spotlight. These pictures, surreptitiously snapped through a restaurant window by a paparazzo, prove the wisdom of the advice. After taking a mouthful of spaghetti while dining with her husband in Rome, Jackie spotted the photographer, and her displeasure is clear. The offender was quickly dispatched by security.

Jackie seems unperturbed—and the height of seventies fashion—as she prepares to depart London's Heathrow Airport for New York on January 4, 1972, after a reported row with Ari in the Pan Am Clipper lounge. Both denied they had quarreled and that Ari had changed his mind about accompanying Jackie on the flight. "I am afraid this story comes from some of my lesser friends who seem to be trying to either bury me or divorce me," Ari told reporters. "It is complete nonsense. I am joining Jackie in New York next week." Added Jackie, "The children are back in school [in New York] for the winter, so I won't be back in Europe for some months."

Despite the denials, the Onassises were indeed having marital difficulties, punctuated by long periods apart and Ari's explosive reactions to the bills he kept getting after Jackie's shopping sprees.

In New York on March 9, Jackie arrives at Federal Court to be cross-examined in a $1.3 million lawsuit filed against her by photographer Ron Galella for "interference with my livelihood as a photographer." She had had Galella arrested for harassment after years of trying to avoid his constant attempts to photograph her and her children. Galella chased her in automobiles, ambushed her from behind bushes, circled her as she walked down the street. Once, assigned by the *National Enquirer* to shoot her with Santa Claus for its Christmas cover, he hired a man to wear a Santa costume and accost her as she left her Fifth Avenue apartment. Jackie fled; Galella didn't get his picture.

She countersued him for $6 million, charging that his actions invaded her privacy and caused her mental anguish. She said she was "an absolute prisoner" of the man and was "terrified" of what he might do next. The judge dismissed Galella's suit and granted Jackie an injunction that prevented the lensman from getting within twenty-five feet of her and thirty feet of the children.

June 5, 1972: Roger Stevens, director of the John F. Kennedy Center for the Performing Arts in Washington, D.C., escorts Jackie past a bust of the late president as she makes her first visit to the facility she helped plan as first lady. Later she attended composer-conductor Leonard Bernstein's *Mass,* dedicated to JFK.

The next day, the pain of her memories is clear on Jackie's face as she stands by Robert Kennedy's grave at Arlington National Cemetery. She and members of the Kennedy family took part in a Mass to observe the fourth anniversary of the senator's death.

At London's Heathrow Airport, Jackie sees Caroline and John off on their flight to New York on August 8, 1972. Jackie remained a few more days at the Radziwills' country estate before following the children to New York.

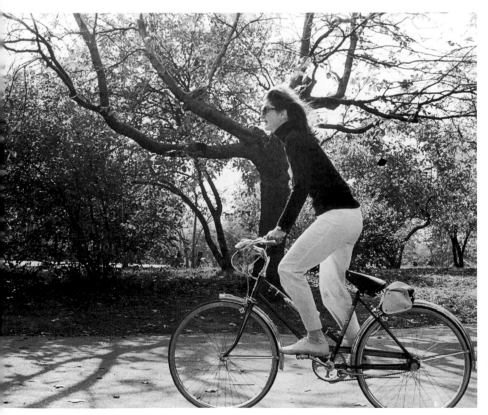

Back in New York, Jackie rides her bike through Central Park. By now she no longer feared for her children's lives, but John did have a scare around this time. Cycling through the park on his way to a tennis game, John was mugged by a man who jumped out of the bushes and demanded the boy's bike and tennis racket. He was unharmed, and the man was caught, but Jackie didn't press charges for fear a trial would turn into a media circus.

An intimate telephoto lens picture in April 1973 shows us a stretching Jackie and a brooding Ari. Less than three months earlier Alexander Onassis had been killed in a hydroplane accident. His only son's death devastated Ari, whose personality changed from ebullient and full of life to moody and angry. Jackie tried to keep his spirits up, planning trips and inviting friends he enjoyed to dinner, but to little avail. "I saw the biggest fights between them you could ever imagine," their friend Peter Beard said. "He would blow up all the time—tantrums about everything. Yelling and screaming at her."

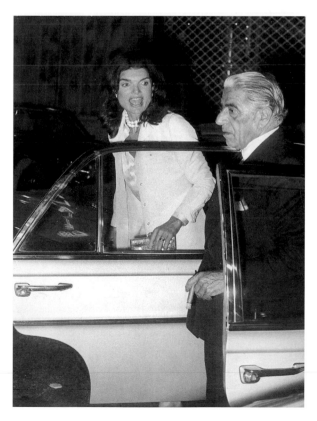

Jackie and Ari arrive at Maxim's, the trendy and fashionable restaurant near their Avenue Foch apartment in Paris, on the evening of October 4, 1973. They dined with eighty-three-year-old Rose Kennedy, who was in town on one of her frequent European trips. Onassis had been suffering headaches and fatigue, which worsened his mood and his heartache. He was soon diagnosed with myasthenia gravis, a rare, incurable disease with symptoms resembling those of a stroke. In order to keep his right eyelid from constantly closing, he had to tape it open.

Jackie leaves St. Bridget's Church in Peapack, New Jersey, with Caroline and John after a memorial service on the tenth anniversary of President Kennedy's assassination. The family spent the Thanksgiving holiday at their weekend retreat in Peapack, where they also celebrated John's thirteenth birthday on the twenty-fifth and Caroline's sixteenth birthday on the twenty-seventh.

Mr. and Mrs. Onassis relax on a boat as it glides along the Nile River during a trip to Egypt, March 28, 1974. Their apparent serenity belies the volatility of their relationship at this point. When her initial attempts to bolster Onassis's moods failed, Jackie had little recourse but to give as good as she got, and their rows were often spectacular. "She had a very sharp tongue indeed," Gore Vidal said, "and knew when to go for the jugular." On a return flight after a trip to Acupulco, the couple had a particularly nasty fight in which Jackie pointed out the less attractive side of Onassis's earthy joie de vivre—"slurping soup, making animal noises when you eat. It's disgusting!"

The Onassises began to spend longer and longer periods apart; Jackie traveled even more than usual and lived primarily in New York, where the children were in school.

Concern clear on their faces, Onassis's daughter, Christina, and Jackie arrive at the Hôpital Américain de Paris, where Ari was taken following his collapse in Athens with severe stomach pains on February 3, 1975. He underwent gallbladder surgery on the ninth. The operation was complicated by his other health problems, and after a month he slipped into a coma.

Jackie commuted between New York and Paris for a month while Ari lay hospitalized. On March 13, she returned to her Fifth Avenue apartment after a visit and telephoned Ari's sister. She was told that he was holding his own. Two days later Onassis took a turn for the worse, and before Jackie could pack for a flight back, he had died.

The news flash brought out hundreds of the curious, and police had to clear a path through the throng for Jackie.

En route to the funeral in Greece, she wrote a statement to be released to the press: "Aristotle Onassis rescued me at a time when my life was engulfed in shadows. He brought me into a world where one can find both happiness and love. We lived through many beautiful experiences together which cannot be forgotten, and for which I will be eternally grateful."

Jackie strolls the streets of New York City, where she lived permanently following the death of Aristotle Onassis.

Working Woman

Enormously wealthy now, she longed to be her own woman. She craved a creative outlet and intellectual stimulation. Her choice of a career, a surprise to many at first, in retrospect seems inevitable, because her love of books had always been abiding. At the age of six her mother discovered she had been reading Chekhov. "Didn't you mind all those long names?" Janet asked her.

"No," she replied. "Why should I mind?"

The life she had led had been more fantastic than any novel, and so she craved, too, a measure of normalcy. She took a job as a consulting editor that paid her $10,000 a year. She typed her own letters, carried her own manuscripts to the copy room, made coffee for the staff. She seemed to love it. "Like everyone else," she said, "I have to work my way up to an office with a window."

Coworkers expected a dilettante, but she turned into a real editor. She worked on a collection of Lincoln daguerreotypes and coffee-table books on Russian style and courtly life in India. She edited bestsellers including *The Last Czar,* and fought to acquire Joseph Campbell's *The Power of Myth.*

Outside of work, she took on causes, notably helping to save Grand Central Station from demolition. Her celebrity status never waned; her privacy was constantly invaded. But she succeeded in creating a life for herself and her children as nearly normal as could be expected.

After her second widowhood, her friend George Plimpton summed up, Jackie "came into her own. . . . I sensed a change in her . . . very much more like the girl I first knew, who had a great sense of fun and enthusiasm. It must [have been] an electrifying, extraordinary thing for her to be on her own—she was always somewhat diminished by the men around her."

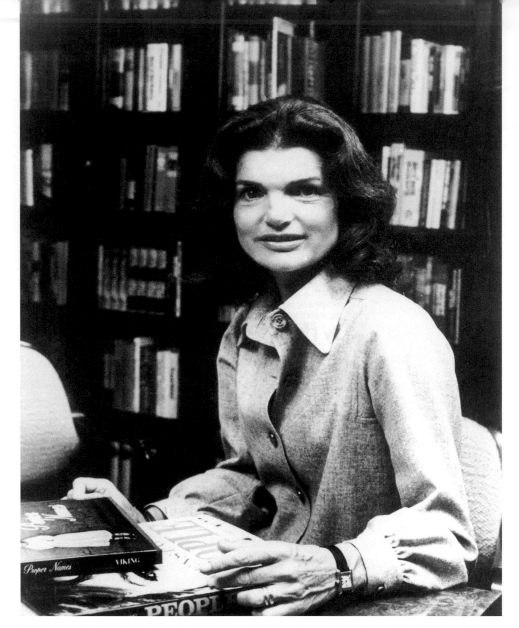

"Who, me? *Work?*" Jackie had exclaimed when Letitia Baldrige, her White House social secretary, suggested she get a job to relieve the monotony of her life. But she soon warmed to the idea of working for a publisher. "I love books," she said. "I've known writers all my life."

Her first day on the job, September 22, 1975, she posed for this photo at her desk at Viking Press. Her consulting editor position paid her $200 a week; clearly her reasons for taking the job were more feminist than financial. "What has been sad for many women of my generation," she told *Ms.* magazine in 1979, "is that they weren't supposed to work if they had families. . . . What were they to do when the children were grown? Leave their fine minds unexercised? You have to be doing something you enjoy. That is a definition of happiness: 'complete use of one's faculties along lines leading to excellence in a life affording them scope.'"

Jackie tosses the dice as she plays Counterstrike, a new board game, with its inventor, Roger Tuckerman, in November 1975. Jackie agreed to help publicize the game, derived from backgammon, because Roger is the brother of her lifelong friend and assistant Nancy Tuckerman.

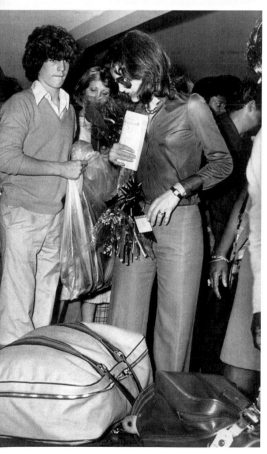

Montego Bay, Jamaica, March 21, 1976. Jackie and John Jr. claim their baggage at the airport terminal as they arrive for a two-week vacation. They stayed at the posh resort Round Hill, and once again the holiday became a cat-and-mouse game with the paparazzi—mainly photographer Vince Eckersley and reporter Rod Gibson, who had been sent by the *National Enquirer* to do a story on her.

She managed to evade them at every turn—except toward the end of the trip, when they saw her alone on the beach at dusk. "It was a perfect photo situation, the moment we'd been waiting for," Gibson recalled. "[Eckersley] picked up his camera; I don't think Jackie even saw us at first, but there was something so regal about her, and so wondrous about the moment, with her alone like that, that Eckersley couldn't bring himself to take the picture. She walked to the water's edge, doffed her beach jacket, and went in for a swim; just sort of glided off like a water bird of exotic origin."

Back in New York in May, Jackie attends an exhibit in the Hall of Gems and Minerals at the American Museum of Natural History. The collection of diamonds on display, some of them the most illustrious in the world, was worth $25 million. Cynical observers joked that Jackie must have been tempted to buy them all, but in fact she rarely wore more than simple pearl necklaces and bracelets.

Jackie and her nephew Tony Radziwill watch the proceedings at the Democratic National Convention in New York, July 13, 1976. The party nominated Georgia Governor Jimmy Carter for president, but Jackie's support for him was lukewarm, especially since her brother-in-law Sargent Shriver had been one of his rivals. The party's 1972 nominee, George McGovern, recalled that Jackie peppered him with questions about Carter. "She asked a lot of precise, intelligent, highly sophisticated questions. She just wasn't sure if he was strong enough or good enough to be president."

Later in the month, Jackie took the wheel of the Staten Island Ferry as she returned to Manhattan following a tour of the Snug Harbor Cultural Center on Staten Island's north shore.

The artist Bill Walton, a longtime friend, escorts Jackie to a $5,000-a-plate fund-raiser at the Metropolitan Opera at New York's Lincoln Center, November 7. Jackie and Princess Grace of Monaco were co-chairs of the event, a tribute to Josephine Baker. Princess Grace did not attend.

Ten years earlier, Jackie had become embroiled in the controversy surrounding demolition of the original opera house at Broadway and Thirty-ninth Street. She served on a committee urging that the eighty-three-year-old structure be saved, a position that displeased the opera's director, Sir Rudolf Bing, who publicly chastised her. By 1976, two successors to Bing as director of the opera had made amends with Mrs. Onassis, who became one of its greatest benefactors.

John Jr., Caroline, Jackie, and Pat Lawford listen to a tribute to JFK during the groundbreaking ceremonies for the Kennedy Library at Boston's Columbia Point, 1977. Jackie involved herself in every aspect of the library's construction, so much so that she would make unannounced visits to the site to assure that things were being done correctly. If they weren't, watch out. "She threw temper tantrums about one thing or another all the time," a subcontractor said. "It got so when one of the guys spotted her, everybody hid."

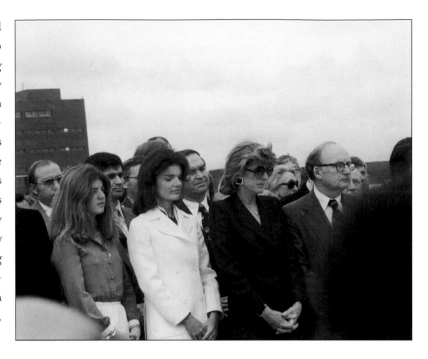

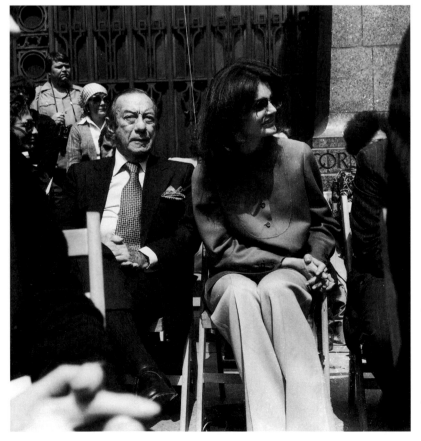

Despite her inability to save the original Met, in 1975 Jackie plunged into another campaign to preserve a New York City landmark, this time Grand Central Station. She became a board trustee of the Municipal Arts Society, which had sued the Penn Central Railroad to prevent the cash-strapped company from selling the land beneath the station to developers. Jackie knew that the best way to win the case was to rally public support. She put her star power to work by speaking at fund-and-awareness-raising events like this one, with former New York Mayor Robert Wagner, on April 21, 1977, in Manhattan.

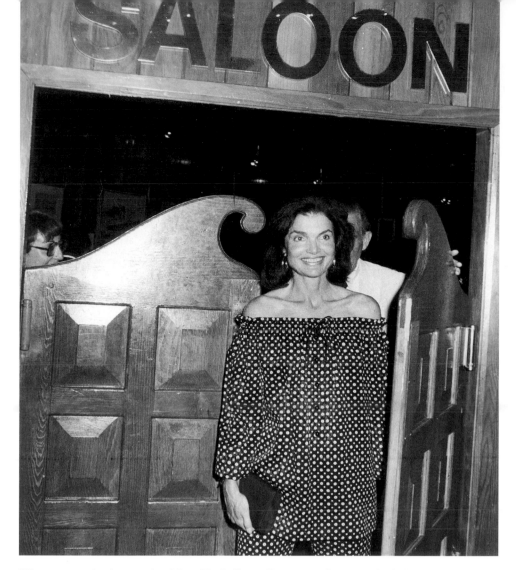

Three months later, the New York State Supreme Court ruled that the station's landmark status prevented its sale. Jackie celebrated the victory at a private party in the saloon of Grand Central's popular Oyster Bar.

The preservationists' joy proved short-lived when an appellate court reversed the decision. The Society decided to press its case all the way to the United States Supreme Court, and Jackie put her efforts into high gear in April 1978. She boarded the "Landmark Express," a train from New York to Washington, D.C., just as the high court was about to hear the case. At a series of stops along the way, she addressed crowds of citizens and dignitaries, explaining the importance of "saving old buildings" all across the country.

Her appearances generated tremendous publicity and turned historic preservation into a cause célèbre. Soon thereafter, the Supreme Court ruled against Penn Central, and the station was saved. Justice Lewis Powell commented that he and his fellow justices "were very impressed with the public interest in this issue"—interest that would not have been nearly as great without Jackie Onassis's involvement.

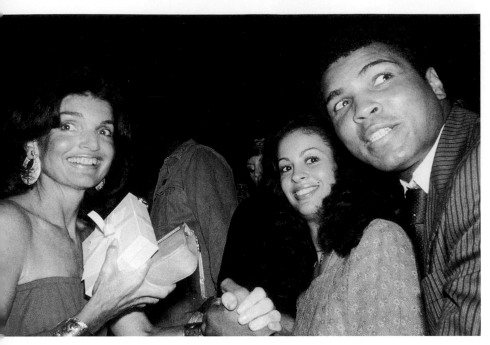

Jackie greets heavyweight boxing champ Muhammad Ali and his wife, Veronica, at a party at New York's Rainbow Room, August 26, 1977. The event kicked off festivities for the annual Robert F. Kennedy Tennis Tournament at Forest Hills, which was scheduled to begin the next day. Proceeds from the tournament go to help underprivileged children, and Jackie lent her presence to the event almost every year.

A rare photograph of Jackie on two counts: She's smoking in public, and she's in the company of the new man in her life, millionaire diamond merchant Maurice Tempelsman. Jackie met Tempelsman, a month younger than she, in 1958, and the couple had begun dating in 1975. At first they tried to keep their relationship secret because Tempelsman was a married man. The press left them alone for the most part, but observers reported seeing them at posh restaurants like La Côte Basque and Lutèce, whispering intimacies and staring into each other's eyes. "He obviously makes her happy," said a fellow diner. "She's constantly laughing and smiling."

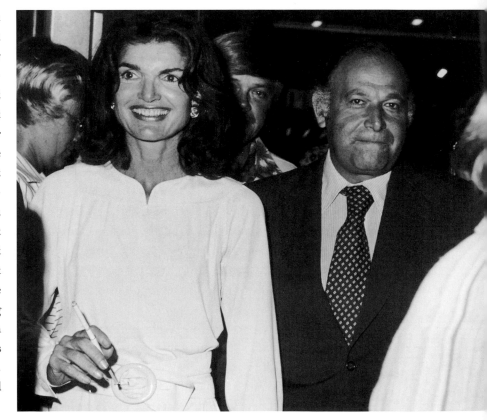

Still in her riding togs, Jackie picks up a few items at a store near her weekend home in Peapack, New Jersey, on October 15. A few days earlier, she had resigned her job at Viking Press over their publication of a Jeffrey Archer novel in which Ted Kennedy is the object of an assassination plot. Although the firm claimed that she was aware of the book from the beginning and that they would not have acquired it unless she had approved, others say she learned that Viking planned the book only after it was signed up, and was not told the plot. She issued a statement explaining her decision to leave Viking: "When it was suggested that I had something to do with acquiring the book and that I was not distressed by its publication, I felt I had to resign." Within a year, Jackie had found a new employer, Doubleday, where she remained the rest of her life.

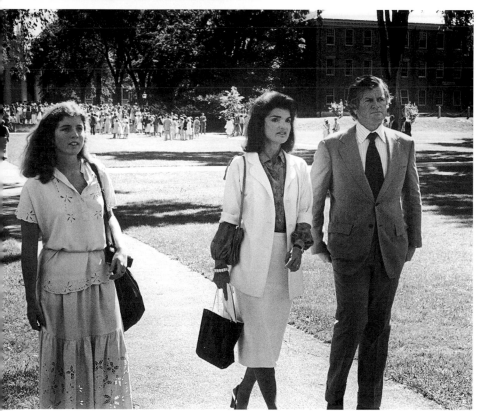

Jackie, Ted, and Caroline arrive at Phillips Academy in Andover, Massachusetts, for the graduation of John Jr., June 7, 1979. The handsome, strapping young man had developed a strong interest in acting, which continued through his college years at Brown University. Although he showed talent in various student productions, Jackie virulently disapproved of her son becoming an actor. "His mother laid down the law," said one of his classmates. "She told John that he was his father's son and that he had a tradition of public service to uphold. . . . They had terrible fights over this." Finally John relented, and decided to pursue a degree in law.

During a brief sojourn to Paris in
September, Jackie arrives at a
restaurant and stops several sand-
wich munchers in their tracks.

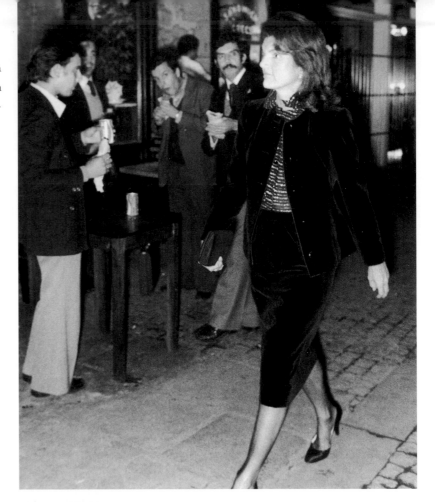

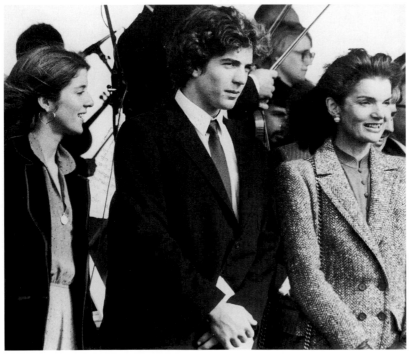

One month later, Jackie and her
children attended the dedication
ceremonies for the John F.
Kennedy Library and Museum.
After more than fifteen years,
Jackie's dream of a fitting memo-
rial for her martyred husband
had come to fruition. The sleek
glass-and-steel I. M. Pei struc-
ture at the edge of Dorchester Bay
reflected both JFK's modernity
and his love of the sea. Inside, a
museum featured a miniature of
the White House, and the
research library made unprece-
dented use of audio and video
records of Jack Kennedy's life
and presidency.

Jackie arrives at Boston's historic Faneuil Hall with Pat Lawford on November 7, 1979, to hear Senator Ted Kennedy announce that he will challenge President Carter for the Democratic nomination in 1980. Jackie was as concerned about a possible assassination attempt on the senator as the other Kennedys, but once Ted's decision to run was firm, she offered her active support. She campaigned in New York's Spanish Harlem, speaking to the crowd in Spanish, and appeared before fifteen thousand at a Greek-American fund-raiser in Queens. She told them that the sound of bouzouki music made her "homesick."

Jackie helped Ted win the New York primary, but he came up several hundred votes short of snatching the nomination away from Carter. Although she felt disappointment for Ted, Jackie also thought losing might have saved his life—a view vividly reinforced less than a year later when President Reagan, in office just two months, was shot and nearly killed by John Hinckley.

On June 6, 1980, Caroline, twenty-two, and her cousin Michael Kennedy were graduated from Harvard and Radcliffe Colleges in Cambridge, Massachusetts. Present to celebrate with them are John Jr., Uncle Ted, Jackie, and Michael's sister Kathleen.

Behind Jackie and Michael stands Ed Schlossberg, Caroline's beau and future husband. She had met the thirty-five-year-old multimedia artist (and holder of a doctorate) while working in the film and television department of the Metropolitan Museum of Art.

In 1980, the Kennedy Library became the repository for the papers of the novelist Ernest Hemingway. In July, Jackie attended the ribbon-cutting ceremony that opened the facility's Hemingway room. With her is Hemingway's grandson Patrick.

On July 28, 1980, Jackie's long-time friend director Mike Nichols escorted her to the opening of a new production of *The Pirates of Penzance* at the Public Theater in Central Park. Nichols was one of several men who could be counted on to accompany Jackie to various functions in New York, sometimes on very short notice. At one point Nichols told her, "Taking you any-place is like going out with a national monument."

"Yes," she responded, "but isn't it fun?"

Not so much fun was the reappearance of the dreaded Ron Galella, who repeatedly violated the injunction that barred him from coming within twenty-five feet of Jackie. On July 21, 1981, he got a tip that she had gone to an Eighth Avenue revival cinema to see *Death in Venice*. He accosted her as she left the theater, and several more times over the next few weeks. Jackie took the photographer to court again, and this shot by David McGough, who had accompanied Galella to the theater, was used as evidence that Galella had indeed violated the injunction. Jackie testified tearfully that the paparazzo "was blocking my path. He was as close as a foot. I wanted to get away . . . but he was jumping all around in front and in back of me. . . . I was frightened and confused."

The judge ruled that Galella had to stay two hundred yards away from Jackie, never photograph her again, and pay her $10,000. Galella said he hoped Jackie would endorse the check so "at least we'll have her autograph. But she didn't even give us that satisfaction—she had Nancy Tuckerman sign it for her."

Jackie made relatively few public appearances in the eighties; most often she appeared at charity or arts events. Here the Greek director Michael Cacoyannis escorts her to a dinner party at the trendy New York nightspot La Coupole. The party was in celebration of the world premiere of *Come Dog, Come Night,* a French play held at the La MaMa Annex to benefit the Ubu Repertory Theater.

"Good Lord! It's Jackie O!" A priest seems delighted to spot Mrs. Onassis as she takes her regular early-morning jog near her Fifth Avenue apartment on May 25, 1983.

On the twentieth anniversary of President Kennedy's assassination, Jackie went up to the Kennedy compound in Hyannis Port to watch a Washington, D.C., memorial service on television with the rest of the family. After the service, she took a long, solitary walk on the same beach she and Jack had frequently strolled.

April 1984: An umbrella and scarf protect Jackie from the rain as she leaves her limousine for a Broadway performance of the new Stephen Sondheim musical *Sunday in the Park with George.*

Maurice Tempelsman accompanies Jackie to the fourth annual Literary Lions Awards to benefit the New York Public Library in the summer of 1984. "This is my favorite charity," she said.

September 1984: Jackie and Maurice go boating off Martha's Vineyard. Two years earlier, Maurice and his wife, Lily, separated and Maurice moved into the Stanhope Hotel, a few blocks from Jackie's apartment at 1040 Fifth. Several times he was seen leaving Jackie's building in the early-morning hours, wearing pajamas under a top-coat.

Granted a *get,* a Jewish divorce decree, Tempelsman moved in with Jackie in 1985. They remained together until her death—the longest romantic relationship of her life. "Maurice gave her complete peace of mind," Jackie's longtime friend Vivien Crespi said. "Husbands did not always treat her the way she deserved. Maurice, however, worshiped the ground she walked on. . . . They were equals. . . . I had never seen her that happy or relaxed with anyone."

Lee Radziwill chats with her sister at an American Academy and Institute of Arts and Letters awards ceremony, May 15, 1985. Over the years, Lee had had a series of personal problems. She underwent a hysterectomy, had an extramarital affair with the handsome photographer Peter Beard, and divorced Prince Radziwill in 1974, two years before he died. Lee then embarked on several other ill-fated romances, ultimately canceling a wedding to millionaire hotelier Newton Cope five minutes before the ceremony was to begin.

Lee developed a drinking problem that often required Jackie to take care of her niece and nephew, Tony and Tina. In 1981, Jackie insisted that Lee seek help, and personally escorted her to an AA meeting in East Hampton. The former princess conquered her drinking problem and, three years after this photo was taken, married the film director Herbert Ross.

Caroline, Jackie, and John attend a fund-raiser at the JFK Library on October 4, 1985.

April 25, 1986: Jackie arrives at Barnstable Airport on Cape Cod for the wedding of her niece Maria Shriver to movie star Arnold Schwarzenegger . . .

. . . and the next day, John escorts her into the church. Jackie must have been particularly touched when the vows were exchanged—she was in the midst of helping to plan her own daughter's wedding.

Jackie allows a rare public display of emotion as she leans tearfully on Ted's shoulder after Caroline's wedding to Ed Schlossberg on July 19, 1986. The marriage took place at the Church of Our Lady of Victory in Centerville, near Hyannis Port. John Kennedy and Maria Shriver Schwarzenegger were best man and matron of honor. Afterward, 425 guests celebrated at the Kennedy compound, dining beneath white tents lighted by Japanese lanterns.

At the bridal dinner the night before, John had made a toast to his soon-to-be brother-in-law. "All our lives," he said, "it's just been the three of us. Now there are four." Doris Kearns Goodwin later told Jackie that she aspired to have the same closeness with her children. "It's the best thing I've ever done," Jackie replied.

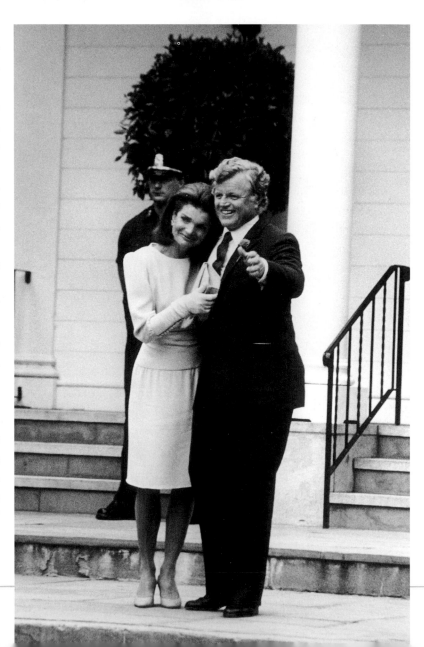

October 1988: Jackie's too engrossed in her book to notice the photographer as she walks down a Manhattan street. She had been a book editor for thirteen years, and had gotten her office with a window in 1984. Her star power helped persuade major celebrities, including Michael Jackson, to sign up their memoirs with Doubleday. (A disappointment, however, was Barbra Streisand's decision not to write her autobiography despite the fact that Jackie flew to California to meet with her.)

"Here's someone," Doubleday president Stephen Rubin said of Jackie, "who produced a large number of bestsellers simply by, in essence, opening up her own sensibility, and in turn finding that it was somehow a universal one among readers. She was a formidable sponsor of projects . . . unselfish and funny when presenting books at editorial meetings."

To her, Jackie told *Publishers Weekly,* "a wonderful book is one that takes me on a journey into something I didn't know before. . . . One of the things I like about publishing is that you don't promote the editor, you promote the book and author. I'm always optimistic that people will buy good books."

Jackie, nearing sixty years old, gets a lift at Heathrow Airport in London as she returns from a vacation to India in the spring of 1989.

part seven

Grand Jackie

Agrandmother now, a national treasure, she was redolent of history, and the apotheosis of dignity and class. Her mother died in 1989, and one-hundred-year-old Rose Kennedy could neither walk nor talk, so Jackie quietly became the Kennedy family matriarch. The paparazzi frenzy faded; the public's unquenchable thirst for Jackie O gossip gave way to an abiding affection and awe-tinged respect.

She doted on Caroline's children, Rose and Tatiana, who called her, aptly, "Grand Jackie." They visited her apartment at least once a week, delighted by the huge red wooden chest full of little treasures that she kept in her bedroom, and spellbound by the magical tales she weaved for them. "The children loved these visits," said Nancy Tuckerman, "but no more so than Jackie."

She wrote to her daughter to express her joy. "The children have been a wonderful gift to me and I'm grateful to have once again seen our world through their eyes. . . . You and Ed have been so wonderful to share them with me so unselfishly."

In maturity she had found a romantic love with Maurice Tempelsman that lasted longer than any before it. "For those of us who cared about Mrs. Onassis," her friend Roger Wilkins said, "it was comforting—it was terrific—to know she was with somebody who was a good, generous, and gentle man."

Early in their relationship she had fretted, worried how the pressures of a relationship with an icon would affect Maurice. "I truly hope my notoriety doesn't force him out of my life," she said. It didn't. He stayed close to her until the end, walking arm-in-arm with her down Fifth Avenue a week before her death. Her untimely passing shocked the world, and so did the depth of the sorrow it engendered—a sense of loss, one realized, for the incontrovertible end to a magical era in American life.

She was a magician, this Jacqueline Bouvier Kennedy Onassis, and we remain her dazzled audience.

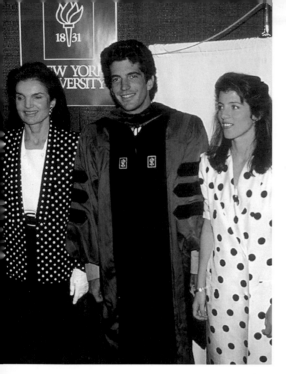

Early in 1989, Jackie reportedly got a full face-lift at Manhattan Eye, Ear and Throat Hospital. Her first public appearance after the cosmetic surgery was at John Jr.'s graduation from New York University's School of Law on May 17, 1989.

John—crowned by *People* magazine as "the sexiest man alive" — had some difficulty with the New York State bar exam, prompting a memorable *New York Post* headline: THE HUNK FLUNKS. After two more attempts, he succeeded, and took a $20,000-a-year job with the New York City District Attorney's office.

Jackie was delighted that John seemed finally to have purged the acting bug from his system. She was reportedly just as pleased when his relationship with the pop singer Madonna ended. She disapproved of the flagrantly sexy star as a companion for her son, and treated her frostily when John brought her to 1040 Fifth Avenue to meet his mother.

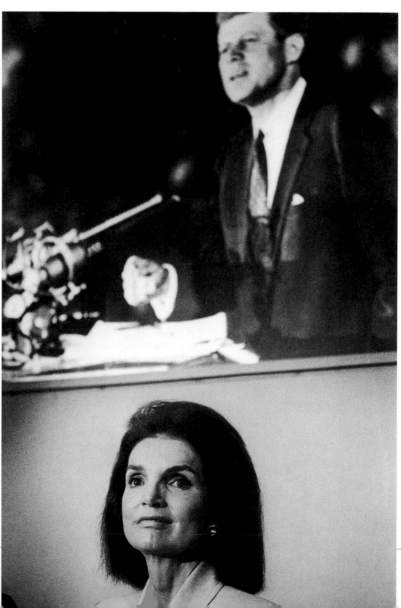

May 25: Jackie looks wistful under a blowup of her late husband as the Kennedy Library commemorates the upcoming seventy-second anniversary of his birth on May 29. A few months later—a week before Jackie's sixtieth birthday—her mother, Janet, died after a long battle with Alzheimer's disease.

162

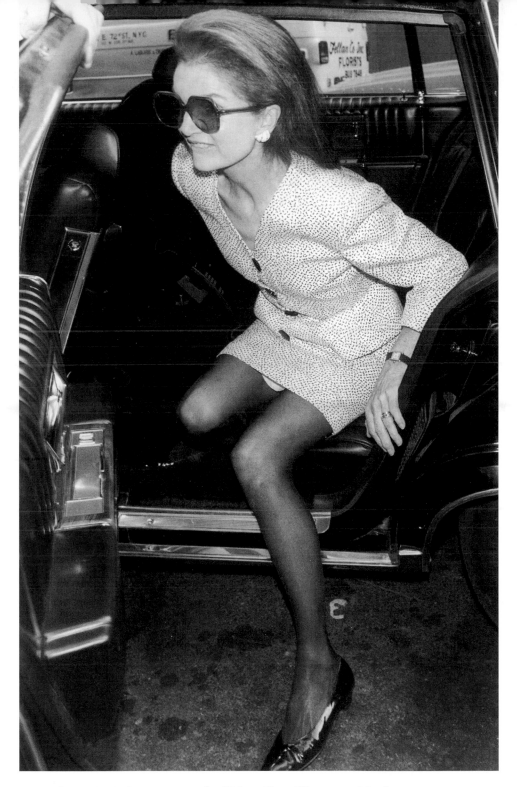

June 18, 1990: Jackie arrives at the Walter Kerr Theater in Manhattan to present an award to the Dance Theater of Harlem on behalf of the Municipal Arts Society. In all, seven organizations and individuals were honored. Other presenters included JFK Jr. and New York's Mayor David Dinkins.

May 1990: At the unveiling of a statue of President Kennedy at the Massachusetts State House in Boston, attended by most of the family, Jackie and Caroline confer under an umbrella. Jackie had deferred to Caroline in the handling of the commission details for the statue.

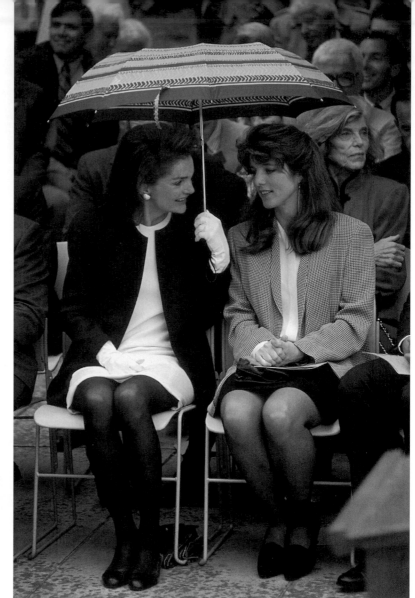

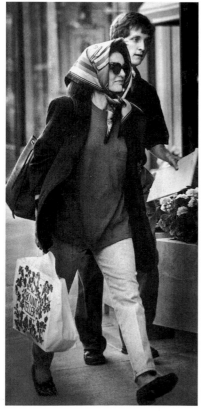

Jackie returns to the Ritz-Carlton Hotel after doing some shopping on Boston's fashionable Newbury Street on May 28, 1991.

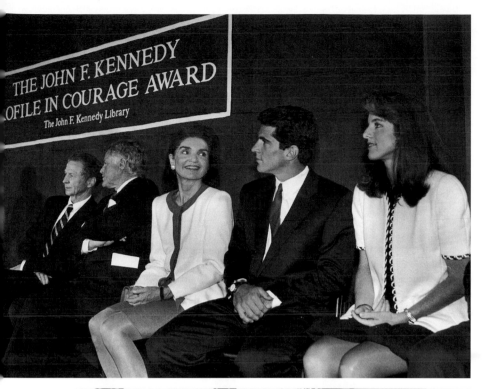

The next day, the seventy-fourth anniversary of President Kennedy's birth, Jackie attended the Kennedy Library's Profile in Courage Award ceremony with Ted, John, and Caroline. With them in this picture is that year's recipient of the award, former Congressman Charles Weltner.

Jackie consults with JFK Library director Charles Daly at the opening of the facility's Stephen Smith Center on February 4, 1991.

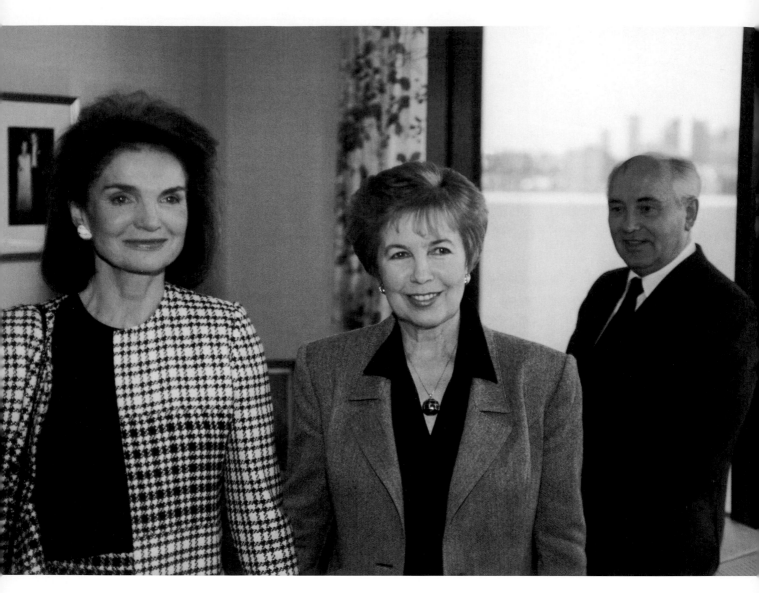

Former Soviet Premier Mikhail Gorbachev steps into the background as his wife, Raisa, poses with Jackie in the Kennedy family's private offices during the Gorbachevs' visit to the Kennedy Library in May 1992.

In the summer of 1993, Jackie walks along a pier on Martha's Vineyard with her grandchildren, Rose, five, and Tatiana, three. That same year Caroline gave birth to her third child, a boy she named John.

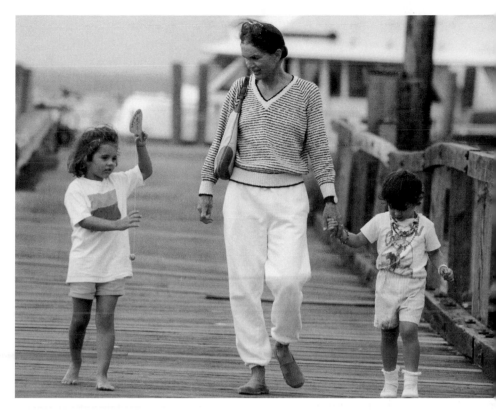

Ted, Caroline, and Jackie look on as John shakes hands with President Bill Clinton at the Kennedy Library's rededication ceremony, October 1993.

Maurice Tempelsman lends a frail Jackie some support as they stroll down Fifth Avenue on May 12, 1994. Three months earlier, she had made public the news that she was suffering from non-Hodgkin's lymphoma, a virulent form of cancer.

She began chemotherapy treatments but continued to work, arriving at the Doubleday offices wearing a wig or turban to conceal her hair loss. She told Arthur Schlesinger that the diagnosis had shocked her. "I don't get it," she said. "I did everything right to take care of myself and look what happened. Why in the world did I do all those push-ups?" She apparently failed to consider the ill effects of her two-to-three-pack-a-day smoking habit.

A week after this walk with Maurice, Jackie succumbed to her disease. Dozens of friends and family members had visited her in her bedroom, where she lay for several days. One of these was Sargent Shriver, who said, "In all these years, I never heard Jackie being nasty or bitter or mean or spiteful. And that imagination she had. Beauty, brains, courage, passion, artistic sensibility . . . She was beautiful when she died. Even illness hadn't ruined her beauty. I was lucky to see her. She was peaceful. Is there any better way to leave this life?"

John and Caroline watch sadly as their mother's casket is placed in a hearse outside St. Ignatius Loyola Catholic Church in New York, May 23, 1994. The funeral service had featured a number of readings, and John Kennedy Jr. told the assembled mourners, "Three things came to mind over and over again and ultimately dictated our selections. They were her love of words, the bonds of home and family, and her spirit of adventure."

Her cortege wended its way to La Guardia Airport, where the funeral party boarded a chartered plane to Washington, D.C. After Jackie was laid to rest beside President Kennedy and their two infant children, President Clinton eulogized the wife of the man who had served as his political inspiration:

"God gave her very great gifts and imposed upon her great burdens. She bore them all with dignity and grace and uncommon common sense. In the end, she cared more about being a good mother to her children, and the lives of Caroline and John leave no doubt that she was that, and more. May the flame she lit so long ago burn ever brighter here, and always brighter in our hearts. God bless you, friend, and farewell."

bibliography

Adler, Bill. *The Uncommon Wisdom of Jacqueline Kennedy Onassis: A Portrait in Her Own Words.* Secaucus, N.J.: Citadel Press, 1996.

Anderson, Christopher. *Jack and Jackie.* New York: William Morrow, 1996.

————. *Jackie After Jack.* New York: William Morrow, 1998.

Anthony, Carl Sferrazza. *As We Remember Her.* New York: HarperCollins, 1997.

Avedon, Richard, with comments by Truman Capote. *Observations.* New York: Simon and Schuster, 1959.

Birmingham, Stephen. *Jacqueline Bouvier Kennedy Onassis.* New York: Grosset & Dunlap, 1978.

Bouvier, Lee, and Jacqueline Bouvier. *One Special Summer.* New York: Delacorte Press, 1974.

Collier, Peter, and David Horowitz. *The Kennedys.* New York: Summit Books, 1984.

Davis, John. *Jacqueline Bouvier: An Intimate Memoir.* New York: John Wiley & Sons, 1996.

Heymann, C. David. *A Woman Named Jackie.* Secaucus, N.J.: Birch Lane Press, 1994.

Kennedy, Rose Fitzgerald. *Times to Remember.* Garden City, N.Y.: Doubleday, 1974.

Leamer, Laurence. *The Kennedy Women.* New York: Villard, 1994.

Spada, James. *Peter Lawford: The Man Who Kept the Secrets.* New York: Bantam, 1991.

Teti, Frank, with text by Jeannie Sakol. *Kennedy: The New Generation.* New York: Delilah, 1983.

Vidal, Gore. *Palimpsest: A Memoir.* New York: Random House, 1995.

acknowledgments

I'd like to express special thanks to my agent, Todd Shuster, and my editor, Michael Denneny, for their good advice and enthusiasm. Thanks as well to James B. Hill and Alan Goodrich of the John F. Kennedy Library and Museum for their good-natured and well-informed assistance, and to John Cronin of *The Boston Herald* for his pleasant and agreeable help. Thanks to Christina Prestia of St. Martin's Press for cheerfully keeping everything moving along smoothly. All those who assisted me at the New York photo agencies have my gratitude, especially Eric Rachlis of Archive Photos, Michael Shulman of Sygma, Henry McGee of Globe Photos, and Ron and Howard Mandelbaum of Photofest. My fellow authors Carl Anthony and Jay Mulvaney unselfishly provided me with leads, and for that I am grateful as well.

As always, family and friends were supportive and understanding, and I send my love to them all: Joe, Richard, and Lewis Spada, Terry Brown, Richard Branson, Ned Keefe, Glen Sookiazian, Laura Van Wormer, Dan Conlon, Chris Nickens, Chris Mossey, Jamie Smarr, and Nick and Kelly Johnson.

photo credits

Curtis Ackerman/*The Boston Herald:* 151

Paul Adao/Sygma: 157, 167(top)

Ted Ancher/*The Boston Herald:* 148(top)

Archive Photos: 44(bottom), 48(top), 50(top), 58(bottom), 60(top), 68, 69(top), 79(top), 103(both), 104(bottom), 108(top), 109, 116(bottom), 117(bottom), 118(both), 121(top), 122(top and bottom), 123(bottom), 127(bottom), 130(both), 131(bottom), 140(bottom), 142(bottom), 146(top), 150(bottom)

Eve Arnold/Magnum: 33

Cecil Beaton/Courtesy Sotheby's: 11

The Boston Herald: 8(bottom), 30(bottom), 101(top), 106(top), 120(top), 153(bottom)

Jim Bourg/Archive Photos: 169

Cornell Capa/Magnum: 36

Laura Cavanaugh/Globe Photos: 168

Patrick Chauvel/Sygma: 156(bottom)

DMI: 163, 164(top)

Ted Fitzgerald/*The Boston Herald:* 162(bottom)

Globe Photos: 25, 37, 104(top), 116(top), 122(middle), 127(top two), 129(bottom), 132(bottom), 134, 144(bottom), 145(bottom), 152(bottom), 158

Glogau/*The Boston Herald:* 18(bottom)

Michael Grecco/*The Boston Herald:* 156(top)

Marshall Hawkins/Archive Photos: 53(top)

Angela Kaloventzos/*The Boston Herald:* 147

John F. Kennedy Library: x, 4(top), 6(top), 7(bottom), 8(top), 19-21, 22(top), 24(top), 26(both), 28, 30(top), 31(both), 32(both), 33(top), 34-35, 44(top), 45(bottom), 47(bottom), 51(top), 57(top), 58(top), 59(bottom), 63(both), 64(top), 86(bottom), 87(bottom), 93(bottom), 94(bottom), 95(top), 96(top

and middle), 97(bottom), 100(top), 101(bottom), 102(both), 105(bottom), 142(top), 148(bottom), 165(bottom), 166

Knudsen/John F. Kennedy Library: 61, 70(bottom), 71(bottom), 76(bottom), 77(top), 86(top), 87(top)

John Landers, Jr./*The Boston Herald:* 155(top)

George Martell/*The Boston Herald:* 164(bottom)

Bert and Richard Morgan Collection/Archive Photos: 4(bottom), 6(bottom), 7(top), 9, 23(top), 27

David McGough/DMI: 149(both), 150(top), 152(top), 154

Arthur Pollack/*The Boston Herald:* 165(top), 167(bottom)

Photofest: 10, 12, 14, 18(top), 20(bottom), 22(bottom), 23(bottom), 24(bottom), 29, 36(bottom), 38, 39, 46, 48(bottom), 49(bottom), 50(bottom), 51(bottom), 55(top), 56(bottom), 57(bottom), 62(both), 64(bottom), 65, 69(bottom), 70(top), 72-73, 75(both), 76(top), 78, 80(bottom), 83, 88, 92(both), 93(top), 95(bottom), 96(bottom), 97(top), 98-99, 100(bottom), 105(top), 106(bottom), 107(both), 108(bottom), 110-112, 117(top), 119(both), 120(bottom), 121(bottom), 123(top), 124-126, 128, 129(top), 131(top), 132(top), 133(both), 138-139, 140(top), 141(both), 143, 144(top), 145(top), 146(bottom)

Brian Quigley/Outline Press: 162(top)

Abbe Rowe/John F. Kennedy Library: 40, 45(top), 47(top), 52(both), 53(bottom), 60(bottom), 71(top), 79(bottom), 80(top), 84(bottom)

Charles Stevens/Globe: 85

Cecil Stoughton/John F. Kennedy Library: 54(both), 55(bottom), 56(top), 59(top), 66-67, 74(both), 84(top)

Sygma: 49(top), 77(bottom)

Molly Thayer Collection/Magnum: 5

Santi Visalli/Archive: iv

Wide World: 81, 82

about the author

JAMES SPADA is a writer and photographer who has written internationally best-selling biographies of Barbra Streisand, Bette Davis, Peter Lawford, and Princess Grace of Monaco. He has also compiled pictorial biographies of Marilyn Monroe, Katharine Hepburn, Jane Fonda, and Robert Redford, among others. He lives in Natick, Massachusetts.